HAUNTED
SANTA CRUZ,
CALIFORNIA

MARYANNE PORTER

Haunted
America

Published by Haunted America
A Division of The History Press
Charleston, SC
www.historypress.net

First published 2016

Manufactured in the United States

ISBN 978.1.46713.603.7

Library of Congress Control Number: 2016939300

In memory of my father, Sir Stanley the Great.

Although I know you're smiling from heaven,
your words of wisdom and lovable wit have never left me.

"You can accomplish anything in life that you want to; you just have to want to…"

"Que sera, sera…Whatever will be, will be"

CONTENTS

ACKNOWLEDGEMENTS

This book is a reflection of my love for legends, myths, folklore and the history of Santa Cruz. Written from a speculative perspective and taken from actual accounts of history as well as lore, this effort and the passion it invokes has taken me on many adventures, from exploring claims of the paranormal to uncovering historic mysteries of long ago. The experiences in which I have taken part are without comparison. However, no adventure would be complete without someone to share it with, and if it wasn't for the many people who have dedicated their time to help me in the creation of these stories, I wouldn't be presenting these works to you now.

First and foremost, a huge thank-you to the Santa Cruz Ghost Hunters team, my dear friends and extended family: Sangye Hawke, Rhiannon Mai, Jay P. Alvarez, Beth Gemeny, Timothy Loe, Aimee Correa and Susie Elaine Dryden. Without your passion, expertise and love for the paranormal and the history of Santa Cruz, I would not have been able to transform my vision into a reality. I truly feel blessed to know you all.

To my childhood sweetheart Michael Sorbet, thank you for supporting me in the creation of this book, as well as tirelessly waiting by my side with words of encouragement.

A special thanks to the amazing historical researchers of Santa Cruz, who assisted me in my quest for information, without question: the Santa Cruz Museum of Art and History; Marla Novo, Paradise Park historian; Barry Brown, SLV historian; Lisa Robinson; the Watsonville Historical Society; Capitola Museum; Sangye Hawke; and Evergreen Cemetery.

Additional thanks go to my mother, Margaret, who maintained her excitement in the creation of these works; even so, I locked myself away from her to complete it (sorry, Mom).

To my children, remember that the past does not define us—it shapes us, and the choices we make in our future help complete us. I love you all and want you to remember as you grow and experience things in life, that these are lessons to be learned. You have to take the good with the bad, and as your grandfather would say, you can accomplish anything in life that you want to—you just have to want to.

I would also like to thank Arcadia Publishing and The History Press for all of your help in the creation of this book.

This work is dedicated to the people of Santa Cruz County. I hope you enjoy *Haunted Santa Cruz, California* as much as I enjoyed creating it.

Legends of Holy Cross

The wire-tipped whip struck down the young child's back for a third time. The sobbing neophyte women huddled in a corner and watched helplessly as the priest relentlessly whipped the innocent Ohlone boy again and again while he wailed in terror and begged for forgiveness. The child's mother knelt before the priest with her arms extended out, her hands folded in prayer, begging for mercy. "Take me padre—please take me!" she cried out in Spanish, but her screams fell on deaf ears.

Blood poured down the young boy's back as his flesh was ripped apart with each vicious lash. His dark-brown eyes filled with panic, and tears fell down his cheeks as pain soared through his little body with every strike. His blood-curdling screams echoed through the moonlit night. The child stood helpless, with his arms stretched out on either side of him, wrists bound by rope. The young boy frantically tried to free himself, but it was no use. With one final swoop, the priest struck the last mutilating blow, knocking the young Native American boy unconscious. His cries were silenced; the neophyte women held their breath in fear that the boy was dead. Consumed by rage, the neophyte men yelled furiously in their native tongue as they were detained by Spanish soldiers. The friars who were observing the punishment grew fearful for their safety and armed themselves with wooden pitchforks aimed at the bellies of the enraged natives. The child's mother knelt nearby sobbing uncontrollably, holding her hands over her mouth to muffle her cries for fear of angering the priest any further. The punishment was finally over.

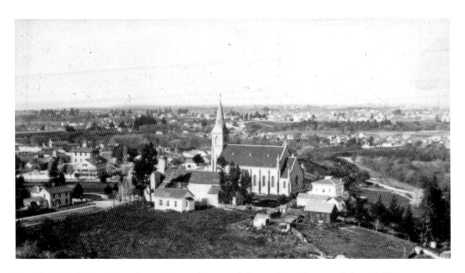

Overlooking Holy Cross, Santa Cruz. *Courtesy of Santa Cruz Museum of Art and History.*

In 1790, nearly three hundred years after Christopher Columbus claimed to have discovered the Americas, Spanish ships lined the littoral seas of the Monterey Bay area in a joint effort to colonize its coastal banks. Its native inhabitants—peaceful villagers known for hunting, fishing and basketmaking skills—looked on the newcomers with a welcoming curiosity. Little did they know that life would soon be changed forever.

The Franciscans gathered on the shores of the prospective new land, and after much survey, they chose a location off what they named the San Lorenzo River, or St. Lawrence, to build the twelfth of twenty-one Catholic missions, dubbed Santa Cruz, Spanish for "Holy Cross." The river was the very lifeline and essence of the Ohlone people, as it fed tribes from the mountainous ranges to the foothills and the coastal beaches and was filled with fish and was surrounded by fertile land. It was a gift to the Ohlone people from the great spirits.

Soon after their arrival, the Franciscan priests and friars befriended the indigenous people and hired them to build their mission in exchange for food and boarding. The friars began to educate the native inhabitants, teaching them Spanish and converting them to Catholicism. Many of the tribe's people entered the mission life of their own free will. They believed that these newcomers from across the vast sea were sent by the great spirits to teach them an important message. Meanwhile, others feared both the friars as well as the priests and stayed close to their native villages.

On August 28, 1791, Father Fermín Lasuén, founder of the Santa Cruz Mission and successor to Junipero Serra, oversaw the creation of the mission and sanctified the soil where the mission would soon be built. Showering the earth with holy water and chanting a religious prayer up toward the heavens loudly enough for God himself to hear, the Catholic priest blessed the ground; a giant wooden cross was erected for all to see. Within a few months, the Santa Cruz mission on the San Lorenzo River was flourishing. Nearby missions from Monterey and San Jaun Bautista furnished the endeavor with supplies such as seeds, horses, cattle and more native workers. Framing began, and the mission's future looked bright.

In October 1791, the first baptism to Christianity occurred, evoking a great celebration that encouraged religious conversion. Once Ohlone natives were baptized and converted to Christianity, they became known as "neophytes," or "new to learn, new to Christianity." Neophytes were not allowed to practice their indigenous cultural religious beliefs and were expected to refrain from speaking in their native tongue, encouraged to only speak Spanish.

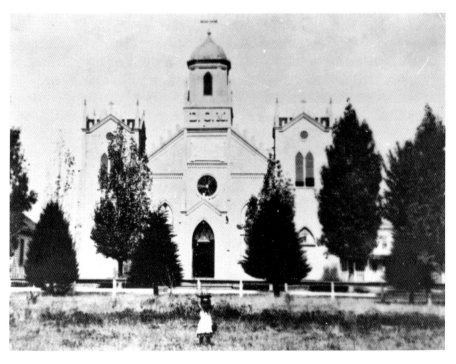

The second Holy Cross Church on top of Mission Hill. *Courtesy of Santa Cruz Museum of Art and History.*

As more natives converted to Christianity, it seemed as though a dark, sinister cloud began to loom over Santa Cruz. The skies grew dim, and rainfall began to ravish the earth. As the San Lorenzo River rose to great heights, the wheat fields and fruit crops began to flood and desecrate the farmlands as far as the eye could see. Because the flooding river waters continued to grow higher and higher, threatening the safety of the mission and its inhabitants, the friars chose to abandon further efforts at the site and move the Santa Cruz Mission to higher grounds. Although the Franciscans chalked it up to poor decision-making by building the mission so close to a river, many of the indigenous people saw this as a warning sign sent by angry spirits. Nevertheless, by 1793, the second Santa Cruz Mission had been built, and it stood high on what was known as Mission Hill, away from potential floodwaters.

It did not take long after the second mission church was built for its troubles to continue. On the night of December 14, 1793, the mission was attacked and partly set ablaze by members of the Quiroste tribe, a powerful coastal tribe primarily based between Monterey and San Francisco. The Quiroste tribe's attack was one of the first and only resistance attacks to be documented in the history of the missions along the Monterey and San Francisco Bay area. According to historical records, the attack was in retaliation for transferring Native American Christians from one mission to the other and separating a Native American woman from her mate. Father Fermín Lasuén, of the Santa Cruz Mission, reported the following:

> I have found out for certain that on the night of the fourteenth of last December the pagan Indians, and some Christian Indians, from the rancherías to the northwest of that mission made an assault on the guard, wounded the corporal in the hand, and another soldier in the shoulder, and set fire to the roof of the corral for the lambs, and the old guard house. The corporal fired a few shots, and with that they withdrew without serious injury to either side. The motive they have given is this, that the soldiers had taken away to San Francisco various Christian Indians belonging to that place who had been fugitives from there for some time, and that they had taken a Christian Indian woman away from a pagan man, and it was he who was the principal instigator and leader of the disorder.

After recovering from the attack, the native population of the Santa Cruz Mission finally reached a peak in 1796 with a recorded population of 523, which was still the lowest in all of the twenty-one missions. However, conditions

for the mission's native population were progressively getting worse. Many of the neophyte inhabitants were contracting sicknesses brought over by the Spaniards and, in turn, plaguing the surrounding indigenous villages with diseases to which the native people had no resistance. Children born to neophytes at the mission typically did not survive past the age of three. Likewise, many of the women became barren as a result of illness. It has also been suggested that mission friars were known to sexually abuse young neophyte women, along with inflicting severe psychological abuse. It is said that women at the mission who were unable to bear children were forced to carry a wooden doll everywhere they went. Perhaps the friars thought this would appease a woman's yearning for a child, or perhaps the motivation was much more sinister and this was just another form of psychological torment and humiliation these proud people were forced to endure. All of these conditions helped fuel credence among natives that the Franciscans were sent by evil spirits, or maybe even conjured up by their enemies to cause their people harm.

By 1797, nearly 140 neophytes were said to have escaped, and nearly 100 of those were hunted down by Spanish soldiers and forced to return to the mission. Punishment for their betrayal was fierce, and many natives were subjected to severe abuse. As the native mission population began to dwindle due to illness, death and desertion, the mission began falling into disarray. Livestock began dying, crops failed and upkeep of the mission dwindled. It became clear to the indigenous people that they were nothing more than slaves to the mission. A year later, in 1798, after the population steadily declined, an estimated 190 more neophytes escaped, leaving an estimated 40 remaining at the mission.

The Spaniards were devout Catholics who believed that only through Christianity would they find the heavens after death, unlike the indigenous population of the Ohlones, whose faith whispered in the winds of every spirit that encircled them, from the smallest creature to the tallest tree, the swiftest river to even the dirt beneath their feet. The Ohlones believed that all things have great spirits and, if not respected, could bestow great consequences, whether good or bad. Even the dead had their place in the afterlife. The Catholics memorialized the life and death of their loved ones by archiving their history, bestowing their belongings on friends and family and placing a marker above their grave so their name would never be forgotten. Native Ohlone tribes held different beliefs. Death wasn't taken lightly, and the whole tribe would mourn a loss together. Tribesman chanted and danced throughout the night singing to the spirits, while the deceased's belongings

were broken and burned. Hunting tools, clothes, skins and even the hut of the deceased were removed from the world as a signal to the dead that they need not return to this realm of the living for these material things.

The deceased's body would either be burned or buried and placed in an unmarked grave, and it was forbidden to speak their name out loud unless a child born was named alike. The Ohlones believed that calling on the dead or keeping their belongings would prevent their spirits from crossing over to the afterlife. Instead, they'd remain among the living, where they no longer belonged.

The young boy's mother crawled to her son's lifeless body as the Spanish soldiers cut the ropes that bound his wrists. Falling into his mother's arms, she breathed a sigh of relief to hear his muttered breath as she prayed to the spirits that his soul was still of this world. Daring not to touch the boy's horrendous wounds, two neophyte tribesmen moved his motionless body into the women's adobe, where he was laid on his belly. The women prepared herbs and medicines for his wounds, quietly chanting prayers for the spirits to heal the boy, while his mother wiped cool water over his face in a silent vigil of her own.

After the beating, Father Andres Quintana retired to his dwelling, satisfied that the boy had learned his lesson for not working in the fields and comforted that the rest of the neophytes would learn by example. He calmly drank a flagon of wine and bedded down for the night. Meanwhile, the neophyte men gathered in their adobe dwelling, consumed by anger at the excessive cruelty imposed by Father Quintana, who was the most despised among the Franciscans and known for his vindictiveness. Calling on their traditional ancestral beliefs, the Ohlones stopped believing that the Spaniards were sent by the spirits to teach and help them through their journey in life. They began to view the men as possessed by wickedness, an enemy to inflict pain and suffering on their people.

As time passed, the boy's horrific wounds gradually began to heal, leaving ghastly scars for all to question. However, the resentment among native neophytes did not heal so easily. In fact, their anger merely festered. Fausta—a handsome, dark-haired, wide-eyed, middle-aged neophyte woman—was married to Julian, a thinly built neophyte, whose job at the mission was that of gardener. Fausta was well respected among the tribesmen of the neophyte missionaries and looked on as a spiritual healer. She began to lead her fellow tribesmen in a conspiracy of retribution that would forever stain the history of Holy Cross for generations to come. Together with the male tribesmen,

Fausta devised a foolproof plan to lure Father Quintana away from the safety of his confines, where they could put an end to his brutality once and for all. Fausta's husband would fake a terminal illness, while she would stay by his side to nurse him for several days to contribute to the ruse. Finally, on October 12, 1812, they hatched their plan.

As the skies grew black and the midnight hour began to encroach, Fausta silently made her way from her adobe to the mission and quietly woke Father Quintana from his slumber. "Padre, padre please, forgive me for waking you," she cried. "It's Julian, my husband, death approaches, please come quickly padre." Father Quintana quickly but quietly reached for his Bible, his cross and anointing oil and followed Fausta out to the courtyard toward the adobe hut near the fields and away from the mission to administer last rites to Julian.

When the padre was far enough away from the mission and out of earshot from the Spanish guards, the native men surprised him, wrapping a rope around his neck to choke him from behind. The friar was no match against his assailants, and the men waited until the padre breathed his last breath. His evil wrath was over. While Father Quintana lay motionless on the ground, several men kicked at him to ensure that he would not rise. They spat on him while cursing him in their native tongue and crushed his genitalia with rocks. Castrating him ensured that his male virility would not spawn further demons in the spirit world.

Fausta reached for a knife and carefully cut a lock of hair from the padre's head before the neophyte men discreetly carried the body back to the mission, into his quarters, tucking his body back into his bed as if he had passed away in his slumber, undetected by neither the Franciscans nor the Spanish monastery guards. The daring deed was a success. Once back in the safety of their confines, the assassins proceeded to unlock the adobe dwellings of both the single men and women, providing a coverup for the conspirators.

Afterward, Fausta and a few of the others who devised the scheme wandered down to the banks of the San Lorenzo River; together they chanted in their native tongue to the spirit world and the waters that they knelt before. They bathed their hands and faces in the river's flowing stream, and they burned a mixture of tobacco leaves, sage and other herbs to purify themselves. Then Fausta asked the great spirits of the flowing San Lorenzo River and the spirits of the land, the wind, the skies and all of Mother Earth to curse these hills and all its nonnative dwellers as a penance for all the pain and suffering bestowed on her people. As long as the river would flow,

so shall the curse—a curse of affliction that would affect Santa Cruz for generations to come. As the herbs began to smoke and the wind carried it toward the heavens, Fausta continued to recite her incantation. Burning the lock of the padre's hair, she blew the ash into the waters of the San Lorenzo River The curse of Santa Cruz was now complete.

The following morning, the friars discovered Father Quintana deceased in his bed, and as planned, they surmised that he died in his sleep and buried his body. However, within a few days, his remains were exhumed by the Monterey Diocese, and the first reported autopsy in California history was performed.

Quintana's death was yet again ruled to be from natural causes, but perhaps this was to discourage further retribution by the native populace. Although Father Lausen requested Quintana's remains be buried under the Holy Cross church to prevent desecration, the exact final resting place of the infamous padre is unknown.

One year later, nine neophytes were arrested for the murder of Father Quintana; however, only two were actually imprisoned, enduring two hundred lashes and a sentence of two to ten years of hard labor. One of the men, by the name of Lino, died in prison, the other served two years and was released. Fausta and Julian were never convicted.

The mission woes of Holy Cross did not end with the murder of Father Quintana. In 1818, a feared pirate named Hippolyte de Bouchard raided the Monterey Presidio, looting and burning buildings. Santa Cruz Mission was sent word of the attack, as well as that the feared pirate was heading toward the mission. The priests decided to immediately move the people at the mission to Santa Clara for safety. Father Ramon Olbes asked the Branciforte officials if they would pack up all the valuables at the mission while he and the mission inhabitants fled to safety. The nearby townspeople of Branciforte agreed, but when they arrived at the mission, they did no such thing. Instead, they looted the mission. The Branciforte people burned some of the buildings, ruined the food and wine supply and stole the very artifacts they were supposed to protect from the pirates. In fact, the feared pirate Bouchard never arrived at Santa Cruz. But the townspeople damaged the mission just as much as he was expected to have done. Father Olbes was so upset and discouraged that he wanted to abandon the mission, but Father Lasuén ordered that mission operations continue.

It would seem that Fausta's curse had indeed awoken an unrelenting plague of misfortune that continued to follow the notorious mission. In 1840, an earthquake toppled the mission bell tower from its perch, a bell tower

that housed nine beautiful harmonious chimes that rang to the heavens high from the hilltop for all of Santa Cruz to hear. On the day of the earthquake, the bells rang a different tune as they crashed to the earth, signaling the mission's demise.

In the years to follow, Santa Cruz Mission would continue to deteriorate, losing the respect of the townspeople and the native inhabitants. Finally, a series of earthquakes continued to forewarn the colonists. In 1857, Mother Earth finally erupted into a violent rage, shaking the ground in its furious wake for all to bear witness as the mighty Holy Cross mission once and for all fell to its foundation. The end of an era had finally dawned.

Despite the mass debris that lay before the Catholic priests, a church in ruins, the padres erected a new church the very next day to continue paying homage to the lord. The church wasn't as ornate as the former one but rather was a small, humble wooden structure that would be used as a house of prayer for the next thirty years. In keeping with the curse over the remains of Holy Cross, the ground beneath the church began to sour and decay. In February 1863, six short years after the earthquake that brought Holy Cross to its knees, human skeletal remains began protruding from the earth of the mission cemetery. Vertebrae, ribs and human skulls began to surface from their shallow entombment—a reminder of the thousands of fallen souls whose essence continued to be desecrated. In 1873, the fallen mission cemetery was finally consecrated. Perhaps it was due to the many bodily remains that continued to mysteriously resurface, or perhaps the diocese was starting to believe that the land was indeed cursed.

The gruesome sight began to spread concern not only for the church itself but also for the townspeople who followed, and efforts began at digging up the Holy Cross Cemetery and the skeletal remains of its inhabitants in order to relocate the burial ground several blocks away.

In 1885, workmen preparing the site for Holy Cross Church on High Street dug up the old Santa Cruz Mission burial ground. They hauled six wagon loads filled with human skeletal remains and some grave markers to a new Holy Cross Cemetery located in Live Oak. There, they reburied the remains of missionaries, their Ohlone Indian converts, Spanish soldiers, Californio caballeros, European immigrants and Yankee loggers—all together in a mass unmarked grave. Maybe this was meant to be the final insult to the lives of those who endured so much degradation, or perhaps this was an effort to remove a curse—one that will continue to reign as long as the San Lorenzo River continues to flow.

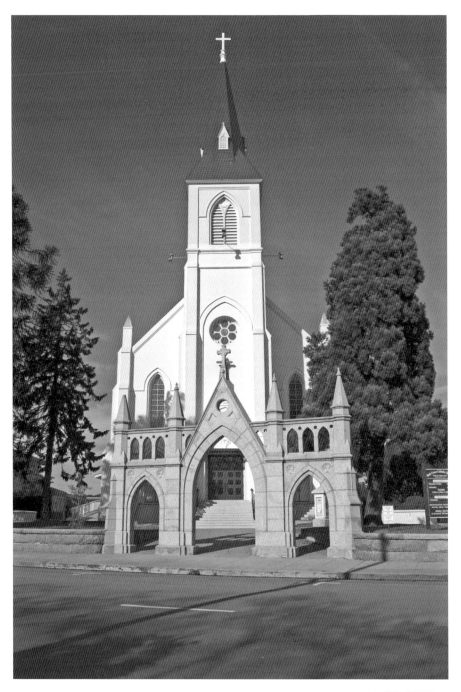

The current Gothic-style Holy Cross Church, Santa Cruz, California. *Courtesy of Santa Cruz Museum of Art and History.*

In 1889, a new Holy Cross Church was built, a beautiful Gothic-style church that still exists today and practices its Catholic tradition. In the 1930s, a small replica of the original mission was built nearby in commemoration to its forgotten past. Nearby there also stands the last original adobe structure, refurbished to its authentic design. This adobe structure once served as the domicile for its missionized Native American inhabitants and is currently used as a museum, educating a new generation in the mission's forlorn past.

To date, local Santa Cruz lore still claims that a curse looms over the lands of Santa Cruz. Many neighboring residents, from the Santa Cruz Mountains of Boulder Creek to the Beach Flats to the fields of Watsonville, all share a common legend of the curse of Santa Cruz. Some say that it was cast by an Indian chief, while others tell tale of the fog fronts blown in from the sea that harbor an evil incantation. Still more believe that it is the river water of the San Lorenzo, whose curse will continue to flow. Regardless of the actual source, one thing is certain: many believe that the legend of Holy Cross is more than just legend.

Regarding the infamous Father Andres Quintana, many believe that his restless spirit continues to aimlessly wander the grounds of Holy Cross Church, serving an eternity of penance for crimes he so wickedly committed on the peaceful people he swore to protect before God. Maybe the many native spirits whose remains rose from the ground, restless in their eternal sleep, prevent him from leaving this place. Perhaps his sentence is to remain in purgatory and be endlessly flogged with a wire-tipped whip forevermore.

According to record, the Catholic Church held a Mass of Reconciliation at the Fifteenth Mission of San Juan Batista for the descendants of mission Indians in 2012; however, no such accommodations of absolution were granted for the dishonorable Father Andres Quintana.

Lynching Over the San Lorenzo River

The angry mob gathered outside the jail, forcing its way in. Many of them were armed with loaded pistols and rifles. They stormed the detention center without causing harm to the on-duty guard. The horde demanded custody of both Francisco Arias and Jose Chamala, two Native American "half-breeds." Both men trembled with fear as the crowd forced them out of their cells. The people threw the two men on the ground, shoving their faces into the dirt as several men from the angry crowd held them down and others proceeded to tightly bind their hands and legs. The two accused criminals were then forced into the back of a buckboard, their fate just moments away.

"Which one of you killed Henry De Forrest? Which one? One of you pulled the trigger!" demanded a large, burly, mustached man wearing a bowler hat. Several young boys picked up rocks and threw them at the two accused killers. Townsmen spat on the pair in disgust, yelling derogatory profanities. There would be no trial for these two today.

The younger of the two accused criminals, twenty-one-year-old Jose Chamala, a Spanish-speaking Mexican Native American who was born nearby in Branciforte, less than half a mile from his current location, quivered in fear of the angry crowd. "I didn't kill him, please, please, it was him, it wasn't me!" Chamala screamed as he begged for his life. Meanwhile, thirty-five-year-old Arias, also a Spanish-speaking Mexican Native American who was not indigenous to Santa Cruz, yelled, "Can't you give us a drink!" A bystander took a bottle of whiskey in hand and placed it up to Arias's lips;

he swallowed the entire contents down before accusing Chamala of pulling the trigger on the gun that killed De Forrest.

"They confessed—they confessed!" yelled one of the men in the crowd, believing that Aria's and Chamala's blame, each on the other for the murder of De Forrest, was proof positive of their guilt. Needless to say, this was all the crowd needed to hear to justify what happened next.

The townspeople had grown weary of the constant thefts and muggings that had been plaguing the small town of Santa Cruz for the last several years. The people had reached their limit when well-respected sixty-two-year-old Henry De Forrest was found murdered on April 28, 1877. De Forrest, a Mason and an employee of the Powder Works Mill, was found shot from behind, the bullet entering between his shoulder blades, penetrating both lungs and lodging in his armpit. De Forrest was found lifeless in a pool of blood; his body had been dragged at least fifty feet in an attempt to conceal the crime. His pockets had been turned inside out; the man lost his life for a mere few dollars.

The thought of "half-breed" thieves graduating from robbery to murder only fueled the racial prejudices of the populace of Santa Cruz. Many residents despised the Californios (Mexican Native Americans). The Californios of the Branciforte were especially heinous and well known for their thieving and dishonest nature; they were considered to be nothing more than a nuisance in the area and were now accredited for robbing and then murdering a harmless elderly white man who was hardworking and respected in the community. This all proved to be more than the locals were willing to bear.

A small mountain of circumstantial evidence pointed to Arias and Chamala as the perpetrators, both of whom had a colorful criminal history. The young twenty-one-year-old Chamala had previously served time in San Quentin for robbing "the widow Rodriquez" in Branciforte, and thirty-five-year-old Arias had served three sentences in San Quentin State Prison, one for murdering a sheep herder in San Luis Obispo and the second for robbing the home of a farmer in Watsonville and a third for "assault to do bodily injury" in Santa Clara County. It would seem that both had recently returned to the area.

On a Saturday evening prior to De Forrest's body being discovered, Santa Cruz police officer Liddell witnessed Arias and Chamala at the circus in the nearby town of Aptos. According to the *Santa Cruz Weekly Sentinel* dated May 5, 1877, the officer was awestruck at the two men's suspicious behavior at the time, and when informed of the murder, he concluded that they knew

something about it. Suspicious, Officer Liddell and Sheriff Hunt visited the Indian village reservation about one mile above town. There they learned from a squaw that an Indian, on his way to the circus, had been stopped by Francisco Arias and Jose Chamala for the purpose of robbery. But when they ascertained the identity of their victim, they realized that they knew one another and bid him "Go on."

Officers lost no time in hunting up the squaw's informant. At first, he was reluctant to tell, giving as a reason that if Arias and Chamala were not arrested and confined, they would take his life as a penalty for testifying against them. Informed of the knowledge in the possession of the officers, he corroborated what the squaw had said, adding to his statement "that after passing Arias and Chamala he met De Forrest and by the time he reached the foundry he had heard two pistol or gun discharges. This was about 10'oclock Sunday."

Armed with this information, the officers immediately went to the house of Chamala's mother near town and ascertained that the men they were looking for had already started for an Aptos picnic at eleven o'clock. Both Chamala and Arias had slept at the mother's house, coming in before midnight; the two had been disputing whether "he" was old or young, Chamala believing that "he" was a boy and Arias saying, "You dumb fool, he was an old man." Chamala's mother exclaimed that Arias had money, gold and silver on his person, something he did not have the previous Saturday afternoon. Officers started immediately for Aptos, but before they reached it, their birds flew the coop. Chamala was ultimately caught without incident in Watsonville, and Arias was caught after fleeing to San Juan. According to police record, Chamala confessed to the attack on Henry De Forrest, claiming that it was Arias who was trying to attain money to take them to the circus. According to Chamala, Arias confronted Henry De Forrest with the intent to rob him. When the man refused, he shot at him, missing him with the first shot but hitting him with a second, which resulted in the fatal wound.

The townspeople listened to the two banditos accusing each other of the heinous crime. They continued with their angry procession up to the upper San Lorenzo River Bridge, currently known as Water Street Bridge. The younger Chamala, begging for mercy that fell on deaf ears, was petrified with fear as the maddening crowd before him forced him and Arias to stand upright on the back of the buckboard. Ropes were passed over a beam above the bridge arches and pulled tightly around the necks of both men. There was no mercy in this crowd today. The driver

Lynching on the San Lorenzo Bridge: Francisco Arias (left) and Jose Chamala. *Courtesy of the Santa Cruz Museum of Art and History.*

of the wagon was told to "move on," and with a quick swipe of the horse whip, he did just that.

Both Arias and Chamala fell heavily. The neck of Chamala was instantly broken by the fall, and Arias strangled quickly. Once the deed was done, the roar of the crowd momentarily subsided, leaving only the sounds of rushing water from the San Lorenzo River flowing beneath the bridge as the townspeople took in the gruesome sight that lay before them, a sight that they bequeathed.

The two accused murderers were left swinging on the San Lorenzo River Bridge for all to see—"a warning to other murderers and thieves; that their fate is but what other murderers and assassins' may expect!!" yelled one of the lynch men, who broke the crowd's silence. As he pointed to the two dead criminals, the people began to cheer.

The spectacle before them was like a festival for all to see. Even children ran about in bare feet, taking souvenirs of rope as a reminder of the eventful day. The bodies of Arias and Chamala were left to swing until dawn. According to the *Santa Cruz Weekly Sentinel*, the following statements were sworn into official record and a verdict made:

> *The people of Santa Cruz, finding that their lives and property were in danger from the number of murders and robberies that have been committed in this county within the past eight years—no legal execution having followed; that the Night Watchman refuses to make an arrest when the robbers are pointed out; that new trials are granted on technicalities; that Arias and Chamala were guilty of the murder of De Forrest beyond a doubt—resolved to hang said Arias and Chamala; that we, tax-payers and conservators of justice assembled to the number of 150; that after due deliberation we resolved that Arias and Chamala should pay the penalty of their crime on the night of the 2d, and that the tax payers in*

this case be free from the expense of a trial and judicial execution; that we went to the jail; that jailor Sylvar refusing to let us into the jail-yard, we broke down the gate.

In an additional excerpt from May 5, 1877, it was noted:

Officer Robert Liddell was sworn, said that he knew the deceased; that their names were Francisco Arias, of San Luis Obispo, and Jose Chamala, of this county; that their respective ages were 21 and 35 years; that he found the deceased hanging from a cross beam on the upper bridge, at 6:00 A.M.

Richard Thompson being sworn, testified he saw the deceased hanging from a cross-beam on the upper bridge; that he did not know them but had seen them.

The verdict was that the deceased came to their death at the hands of parties unknown to the jury.

Although there is only one known photograph of a lynching in the county of Santa Cruz, according to history this was not the first. Another lynching occurred in 1852, when vigilantes hanged a notorious horse thief by the name of Mariano Hernandez, another Branciforte Californio and the leader of an unruly gang of banditos.

To date, historians dispute the guilt of twenty-one-year-old Jose Chamala. Many feel that Francisco Arias, with his extensive criminal history, was solely to blame for the shooting of Henry De Forrest, while Chamala was used as a scapegoat, unjustly executed; his confession to police authorities was likely fabricated to justify the vigilante attack.

Although the entire truth behind this notorious historical lynching will never be known, the haunting tale continues to resonate with Santa Cruz locals, once again substantiating the belief of a curse that befell the city of Santa Cruz and those who dwell within, forever flowing with the waters of the San Lorenzo River.

PSYCHOS

Santa Cruz has had its fair share of psychos. In fact, the city provided the inspiration for Alfred Hitchcock's famous film *Psycho* and its infamous Bates Motel. Hitchcock was no stranger to Santa Cruz. He and his wife resided in the Scotts Valley area at their mountain retreat home between 1940 and the 1970s, hosting Hollywood royals like Grace Kelly and Ingrid Bergman.

The Santa Cruz Bay Area became the muse for many Hitchcock movies, including *Rebecca* (1940), filmed in Monterey; *Suspicion* (1941), filmed in Big Sur; *Vertigo* (1958), filmed in Big Basin; and *The Birds* (1963), filmed in Bodega Bay.

Psycho is one of Hitchcock's most iconic horror/slasher films, and the famous Bates Motel was inspired by a Santa Cruz, California Gothic-style hotel, formerly known as the Hotel McCray. Released in 1960, the movie is about a disturbed hotelman named Norman Bates who lives with his mother high on a hilltop overlooking the hotel residences. Bates goes on a killing spree of hotel guests. The original film was so popular it eventually spawned three sequels, a remake, a TV spinoff and a TV series.

Built in 1883 and perched high on Beach Hill, near the famous Santa Cruz Beach Boardwalk, this once gloomy shell of a hotel was built on Native American burial grounds. The gruesome discovery was unearthed in 1908 by two plumbers named Millo Du Pee and Joseph Tait. According to a *Santa Cruz Sentinel* article dated June 28, 1908, the two plumbers were digging out sewer lines in the vicinity of Beach Hill and Third Street when "Mr. Du

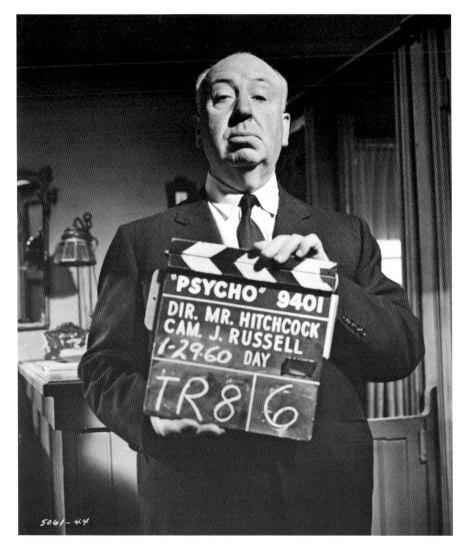

Alfred Hitchcock on the set of *Psycho*. *Courtesy of Paramount Pictures.*

Pee's pick sunk into the skull of skeletal remains." Additionally, a battle axe and small seashells were unearthed. According to the same article, "Sixty years prior there was an Indian graveyard on that portion of Third St."

Local legend maintains that the disturbance of such sacred ground has been the cause of inexplicable supernatural activity throughout Santa Cruz. The story of this grisly discovery is only the beginning of many haunted tales associated with the McCray Hotel.

So what of Alfred Hitchcock's inspiration for the movie *Psycho?* Could the façade of this eerie hilltop hotel be the only motivation for the master of suspense? Or perhaps it merely set the stage for Hitchcock's murderous imagination, as the Hotel McCray was once the center of its own historic murder mystery. On September 9, 1933, a sixty-one-year-old man by the name of Frances Joseph Morgan Grace was gunned down by his former nurse, Frieda Wilhelmina Augusta Welts, age forty-three. A well-to-do shipping man, Grace was in declining health and frequently employed nurses to care for his fragile well-being. Unbeknownst to him, Grace was stalked by the young nurse for nearly eighteen months until he was shot and killed outside his home in the garden of the property adjacent to the McCray Hotel. The case became a front-page sensation of murder and motive.

According to a September 11, 1933 edition of the *Santa Cruz Evening News,* eyewitness testimony of Grace's current nurse, Helena Roberts, noted:

> *Grace was on the lawn with Roberts when she saw the woman walk in the gate. Grace appeared nervous at the sight of her but stepped to one side for a low voiced conservation. As he turned away with a gesture of dismissal Miss. Roberts remonstrated with Mrs. Welts for exciting him.—Suddenly*

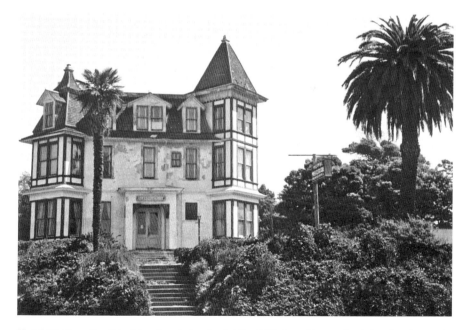

Hotel McCray. Its disturbing façade inspired Alfred Hitchcock's creative juices for the movie *Psycho. Courtesy of Santa Cruz Museum of Art and History.*

> *Miss. Weltz drew a revolver from beneath her coat and fired one shot. The bullet struck Grace in the abdomen from an angle and coursed through his body. His hand to his side, Grace started toward the house. Miss. Roberts screamed. Out ran the butler, Richard Frank. He helped Grace up to the house then ran back to where the two nurses were struggling for possession of the gun. Wrestling the weapon from Miss. Weltz, Frank told Miss Roberts to phone the police.*

Immediately after the shooting, Ms. Weltz withdrew a small vial from her coat and drank the contents in an attempted suicide. The vial contained Luminal, a powerful sedative, and rendered the woman comatose for several hours after the fatal shooting of Mr. Grace. The drug, however, proved to be nonlethal.

Police investigators were able to determine that Ms. Weltz routinely rented a top-floor apartment at the Hotel McCray. Seemingly obsessed with Mr. Grace, Ms. Weltz continued to rent the McCray apartment off and on for the eighteen months leading up to the shooting. The apartment clearly overlooked Mr. Grace's adjacent property and allowed Ms. Weltz to observe Mr. Grace while in his backyard garden. Police were also able to confirm that Ms. Weltz rented a secondary high-top bungalow in another hotel location nearby, where she could observe Mr. Grace's activities from a different vantage point.

The trial of Ms. Frieda Weltz was a speedy one. While most people typically waive their right to a speedy trial, Ms. Weltz, a former military nurse, did not. Investigators hustled to build a strong case against her and determine a motive for this heinous act. Meanwhile, Ms. Weltz kept to herself and confided only in the security of her attorneys. Her only admission was that "Mr. Grace did not keep his promise."

As the trial ensued and large amounts of damning eyewitness testimony was brought forward to the jury, Ms. Weltz and her defense attorney, James Dugan, remained confident that they would prevail and she would be found innocent of all charges. In a *Santa Cruz Sentinel* article dated November 16, 1933, statements from the courtroom read as follows:

> *Labor of almost an entire day on the part of the prosecution bore fruit late in the afternoon when Murphy was permitted by the court to introduce and read into the trial record on the first and second days following the fatal shooting. Admission of the documents was allowed after the prosecutor had painstakingly built a ground-work for their presentation through five*

witnesses. Judge Atteridge ruled, however, that they could be admitted only as evidence and not as confessions. Neither, it developed, nor had been signed by the defendant.

Droning on for almost two hours, Deputy Clerk Loy Miller read them into the record from the witness stand—a faultering, disjointed, almost incoherent story that commenced nowhere and ended just about where it started. To followers for the case it added more uncertainty, more doubt and more speculation over the nature of the defendant's story to be told either today or tomorrow from the witness stand.

In the same news article, Ms. Weltz's testimony was put into record:

ADMITTED DELIBERATION

"Your story is absolutely that you cold bloodedly, deliberately murdered Francis Grace?" was a question of Murphy's read from the transcript.

"Yes" was the nurses answer.

"Yes, I know the consequences of murder," was another one of her answers in the statement. "I am not a young woman. I knew what would happen."

The statement detailed her actions prior to the killing, as she waited in her quarters at the March Rooms of seeing Mrs. Grace and Mrs. Kelly leave the grounds, and her starting across the street and entering the garden through the tradesman's entrance.

"Mr. Grace came up to me and I said 'I came to give you what I promised you.' He knew what was coming, and said 'Can't you postpone it?' He went back to his chair and then he and the nurse started toward the house. When he reached the door the critical thing happened. I shot."

The reading of the statements revealed that time and time again Murphy pressed the woman for a statement of her reasons for the act.

"I had my reasons." "I could no longer stand his lies and insults" and "he wouldn't apologize" were the characteristic replies. Time after time the prosecutor tried for a glimpse behind the sense and each time the enigma of the nurse thwarted him.

The statement reveled that on several occasions Grace had called at Miss. Weltz' San Francisco apartment and that on frequent occasions had met on the street.

"Then you were very friendly?" was a question from Murphy.

"Yes. In a way." Was the Weltz answer.

"Was there a love affair?"

"No, no." was the response.

"Did he ever speak improperly or indecently to you?"

"Did he ever at any time make or suggest sexual advances."

"No." was the unqualified response.

Grace had wronged her; however the nurse insisted in her statement, that she had given him from January until the time of the shooting to rectify it. The nature of the asserted wrong, or the manner in which it could be rectified however, she would not reveal.

"He would not apologize," she had stated.

"Do you mean to say that if he came to you and had said he was sorry that this killing would not have happened?" queried Murphy.

"No, that would have made no difference." Was the nurse's reply.

And so went the statements—two hours of them. The statement of a sane person? Perhaps. District attorney Murphy has three alienists who will say that Miss. Welts is sane now and always has been sane.

Despite Miss Weltz's admission to murdering Mr. Grace in cold blood, she continued to maintain her matter-of-fact composure, and the people of Santa Cruz anxiously awaited to learn what heinous crime Mr. Grace had allegedly committed upon Miss Weltz that cost him his life. In this sensational trial, James Dugan, attorney for Ms. Weltz, finally shed light to the defense in an article from the *Fresno Bee–the Republican*:

SANTA CRUZ, A charge that Francis J.M. Grace a member of a prominent shipping family, drugged and criminally attacked Miss Frieda Weltz, his nurse in June 1932, was made by the defense today in the trial of Miss Welts for the murder of the shipping man.

The charge was made by James Duggan, Pittsburgh, PA, attorney and friend of the Weltz family who came here to conduct the defense. Duggan said Miss. Weltz carried a revolver to the Grace home here last September 9th with the intention of shooting herself to death at Graces feet, and not with a plan to kill him.

CALLED TO STAND

Miss. Weltz then was called to the stands as the first witness for the defense, the state having rested shortly after the opening of the court session this morning.

The accused nurse, 43 years old began the story of her life, beginning with her high school days in Connelville, PA., and told how she had gone

through overseas service during the world war in an evacuation hospital near the front. She then related how she came to San Francisco and took the poison as Grace's nurse.

First Defense Hint
Miss. Weltz was employed by Grace only a short time and the shipping man was being cared for by another nurse when the fatal shooting occurred. Miss Weltz had pleaded not guilty and not guilty by reason of insanity. Duggan's statement was the first intimation of what the defense case would be.

The story of the alleged attack as related by Duggan was that Grace asked Miss Weltz to come to Santa Cruz with him because he wanted to avoid a situation similar to that which existed in his San Francisco home among other members of his family.

"On July 8th," said Duggan, "he made his first advances. On the night of June 9th he drugged and attacked her. She found herself the next morning in a pitiable condition and demanded to be taken home. He took her to her apartment in San Francisco. Time passed and the inevitable happened. She found that she was to become a mother. She advised Grace of her condition.

"He pleaded with her not to have a baby…She took a drug which produced the desired effect. She pleaded with him to furnish money for her to regain her health.

"She came to Santa Cruz repeatedly, not to stalk him but to find him when he was sober and she could talk to him. She had the gun not to kill him but to shoot herself dead at his feet if he refused her the help she wanted. When, instead of sending the nurse Helene Roberts, away so that he could talk to her [Miss Weltz], he started for the house, she determined to end her life that she felt was wrecked."

The prosecution brought forth facts that Ms. Weltz, a trained nurse, had no intention of killing herself and would have known that the dose of Luminal she drank the day of the shooting was not enough to result in her death and so had no intention of suicide. The prosecution also contended that Ms. Weltz stalked Mr. Grace from the window of the McCray Hotel, which clearly indicated premeditation. Furthermore, ballistics revealed that it would have taken a woman of Ms. Weltz's stature nineteen pounds of intended pressure to shoot the firearm that killed Mr. Grace. Finally, prosecution also contended that Ms. Weltz's admission of intent to kill Mr. Grace, which was submitted into evidence early on, was enough to house a

conviction. They believed that Weltz's motive was nothing more than the revenge of a jealous lover who admitted that she wanted Grace to pay her the sum of $300.

After two months of painstaking testimony and arguments, the astounding case was placed in the hands of twelve jurors, consisting of eleven men and one woman. Ms. Frieda Weltz faced death by hanging at the gallows of San Francisco's San Quentin State Prison. On November 24, 1933, after ten and a half hours of deliberation, the jury finally came back with a verdict: not guilty. Ms. Frieda Wilhelmina Augusta Welts was acquitted of all charges.

A spooky hotel perched on a hill overlooking the yards and homes of nearby neighbors; an upstairs balcony window, ideal for lurking behind a cracked curtain; a mentally distraught resident motivated by retribution who stalks his or her prey…money, murder and mayhem—a perfect inspiration for a film called *Psycho*.

Coincidentally, the hotel McCray's infamously haunting history did not end with the Grace murder. Forty years after the death of Grace and nearly a decade after the movie *Psycho* was released on the big screen, the McCray became home to notorious serial killer Herbert William Mullin. Mullin's murderous rampage in Santa Cruz County during the early 1970s led to the deaths of thirteen people, including the execution of a Catholic priest while in his confessional.

Charles Kilpatrick, whose family owned the old McCray Hotel dating back to when it was still known as the Kittredge House, revisited the property in 1986. According to the *Santa Cruz Sentinel*, Kilpatrick recollected a time when Mullin occupied the now dilapidated room. "I looked through his notebooks. They were like a recipe book for making drugs," Kilpatrick said of Mullin. "He was pretty quiet."

Kilpatrick reflected further from when he was a child living in the hotel. "The first time I saw one [a ghost] was when I was 6," Kilpatrick said. "It was a blue energy cloud that started to materialize. It got about as big as a gorilla. It was over there in room two," he said, pointing to a closed door at the end of the hall that leads to the oldest part of the building. "That used to be my room."

Kilpatrick lived in the hotel, and his father ran it until he was nine. They later moved to a house on the Westside, but when his parents died, Kilpatrick returned to the hotel. "Things were pretty quiet…until I fell down the well," Kilpatrik said, as he shifted nervously. "Room two is kind of built over a well."

The brick-lined well evidently was built with the original house. A few years ago, a dog got through the boards that covered the well and drowned. A short time later, Kilpatrick's girlfriend's dog fell down the well. He went after it by wedging an aluminum ladder against the sides. As he started down, it gave way. "I fell and I guess landed on top of the dead dog. I came up treading water in the dark. This was stagnant water. The ladder disappeared. I felt a scratching at my leg and pulled my girlfriend's dog up."

The fire department had to pull him out. The plunge into the well seemed to set off a series of parapsychological sightings around the hotel. "It seems like that is kind of a center of energy," Kilpatrick said. He has since attempted to seal the well off. Upon leaving the McCray Hotel, Kilpatrick had this to say: "I think that the hotel energy is basically good…I mean, good has to win out over evil, or there wouldn't be anything left. Good has to win doesn't it?" he asked as he locked the door.

Transformed from a rooming house to a bordello and then a hotel, the old McCray Hotel is nothing more than a shadow of its former self. Purchased in 1990 for $1 million, it now has been fully remodeled into a beautiful assisted-living facility for the elderly known as the Sunshine Villa. Although restored with a modern outward appearance, the renovations did maintain its historical architecture, and the Sunshine Villa was recognized as a historical landmark in 1998 by the Santa Cruz Museum of Art and History.

However, while the villa appears modern from the outside, it remains a portal to the past on the inside, with a plush design reflecting a 1900s motif, a grand piano and antique furnishings lining its grand corridors, as well as deep-red blush walls and gold accents that remain reminiscent of a historic past.

The staff of the Sunshine Villa appear to frown at the talk of ghosts and specters rumored to walk its halls in the wee hours of the night. Despite staff woes, some personnel, who wish to remain nameless, fearfully recall moments at night, when the halls laid vacant and the residents peacefully slept, when they encountered a ghostly shadow, a tap on the shoulder or spine-tingling goose bumps while walking the halls alone.

A home for the elderly to rest seems an honorable function for this cinema-worthy piece of Santa Cruz history.

In memory of Beverly Pendergraft.

THE BIRDS

*P*sycho was not the only film produced by Hollywood's "Master of Suspense" that was inspired by Santa Cruz County. On August 18, 1961, the streets of the small city in Capitola were riddled with thousands of seabirds, which fell from the sky in an unusual display that can best be described as coming out of a horror movie, as noted by the *Santa Cruz Sentinel*:

> SEABIRD INVASION HITS COASTAL HOMES: THOUSANDS OF BIRDS FLOUNDERING IN STREETS
> by Wally Trabing
>
> *A massive flight of sooty shearwaters, fresh from a feast of anchovies, collided with shoreside structures from Pleasure Point to Rio del Mar during the night.*
>
> *Residents, especially in the Pleasure Point and Capitola area were awakened about 3 a.m. today by the rain of birds, slamming against their homes.*
>
> *Dead and stunned seabirds littered the streets and roads in the foggy early dawn. Startled by the invasion, residents rushed out on their lawns with flashlights, then rushed back inside, as the birds flew toward their light.*
>
> *Television aerial supports were severed, and a power line shorted out at about 4:00 a.m. on Merrill Avenue when the birds hitting the lines slapped them together.*
>
> *The shearwater is a gull like seabird, slightly smaller than a regular sea gull. It looks sooty from a distance, but has a narrow strip of white under its narrow wings and a thin black bill.*

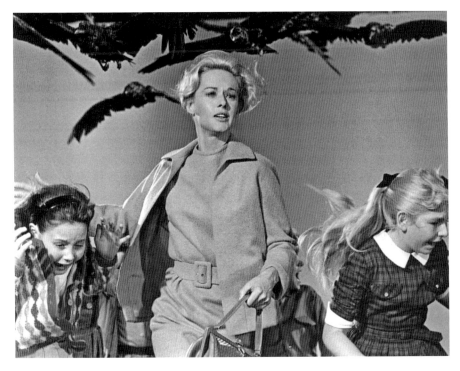

A still shot from the Hitchcock film *The Birds. Courtesy of Universal Pictures.*

According to information from Nils Bergman, state park ranger, they breed on islands of New Zealand and South America and range along the Pacific coast. Sometimes they travel in flocks that number in the millions.

When the light of day made the area visible, residents found the streets covered with birds. The birds disgorged bits of fish and fish skeletons over the streets and lawns and housetops, leaving an overpowering fishy stench.

Gilda and Joe Stagnaro of the Cottardo Stagnaro corporation reported large schools of anchovy off the Rio del Mar area. The invasion started there yesterday afternoon, according to Joe Sunseri, owner of the Pixie Plaza Liquor store near the beach. The most learned explanation of the bird tragedy came this morning from Ward Russell, museum zoologist at the University of California.

He said the shearwaters generally live in the southern hemisphere. As far as they are concerned this is their winter flocking area. Often when they are disturbed while feeding they will rise in flocks from the water. A blinding fog covered the coast last night and this morning.

"They probably became confused and lost and headed for light" he said. The only light available was the street lights and overnight lights in some homes and businesses. One bird flew full speed into a tall light standard.

A sheriff's car prowling through the Pleasure Point area was rammed by several shearwaters as it shined its spotlight into the air.

Richard VonMagus, a teenager visiting on Chesterfield drive rushed out of a home and was struck by a bird. Gibson Walters, 3021 Pleasure Point drive, had to duck a flying bird when he went out a little after 2 a.m. probing with his flashlight.

Russell said that this is a fairly rare phenomenon and it takes certain atmospheric conditions to cause this confusion. He said that during very foggy conditions the lighthouses along the coast are struck by the thousands of seabirds.

It was a pitiful sight—especially watching the live birds struggle for flight or trying to hide themselves.

Mrs. A.E. Stadtmiller, East Cliff drive said she opened her front door at 6 a.m. and several of the birds tried to enter the house. "The smell is terrible." She said. "The birds threw up fish all over the lawn." Cats were dawn to the area and were seen running about the areas.

Youngsters and grownups alike were gathering the live birds in boxes and taking them back to the sea. Once thrown into the water they suddenly became lively and many skimmed over the water into flight. On land they seemed helpless.

When they attempted to take off they would gain partial flight then make a thudding "wheels up" landing on their plump breasts.

A county road crew collected many of the birds off the streets. Mrs. Ethel Gudgel, Pleasure Point drive said she was awakened by the birds "raining" on her roof. Many of the residents said the birds wailed and "cried like babies" as they floundered on the ground. Others said they "quacked" like ducks.

Driving through the streets early this morning I could see little groups of shearwaters huddled under parked cars, on front of porches in alleys behind homes. Many were crushed on the street by autos.

Harry Smith, bird handler from Escolona drive arrived to band 65 birds. A band from another area was discovered on one bird.

Eight persons were reported bitten by the birds. John Blaeholder, Virgil Comstock and Dick Mendonca, Capitola street workmen received tetanus shots. Grant Butterfield, Mike Tille, Jeff Pacassi, Edna Messini and Ted Stanton, were also reported bitten.

Sr. G.L. Dunnahoos county health officer, said he did not believe the birds were a health hazard to humans. Five birds are being sent to the state laboratory for a virus check, however.

The word of the bird invasion spread fast throughout the state. Cameramen from San Francisco papers were out in the early morning fog, and a phone call came to the Sentinel from mystery thriller producer Alfred Hitchcock from Hollywood, requesting that a Sentinel be sent to him. He has a home in the Santa Cruz Mountains.

After Alfred Hitchcock heard word of the Capitola invasion of the birds, he contacted the *Santa Cruz Sentinel* two days later with an inspired request:

ALFRED HITCHCOCK USING SENTINEL'S SEABIRD STORY

Hollywood mystery producer Alfred Hitchcock phoned the Sentinel Saturday to let us know he is using last Fridays edition as research material for his latest thriller.

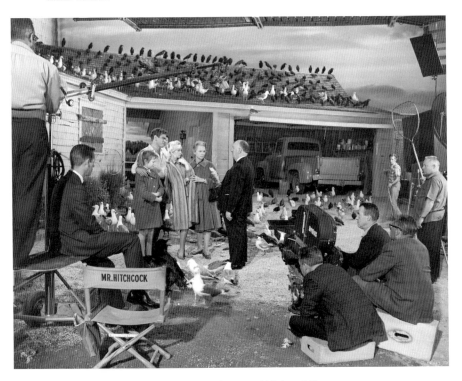

On set of *The Birds* with Alfred Hitchcock. *Courtesy of Universal Pictures.*

Hitchcock, who owns a home in the hills near Scotts Valley, had phoned from Hollywood early Friday morning and requested a copy of the paper be mailed to him there.

It seems Hitchcock is now preparing to film Daphne Du-Maurier's 10 year old novel "The Birds," which ironically deals with the invasion of a small town by millions of birds.

Naturally, he was acutely interested in the similar invasion of sooty shearwaters in Capitola in the wee hours of Friday morning. The story, by feature writer Wally Trabing appeared on the front page of Fridays Sentinel.

Despite its obvious publicity benefits for his new picture Hitchcock denied having anything to do with the feathery invasion of Capitola.

"Merely a coincidence," Hitchcock purred knowingly.

The film *The Birds* premiered on March 28, 1963, in New York City, staring Tippi Hedren and Rod Taylor. The film rated number one out of the top ten foreign film list selected by the Bengal Film Journalists' Association Awards. Hitchcock also went on to receive an Association's Director Award.

SANTA CARLA

In 1987, Santa Cruz was transformed into the fictional city of Santa Carla, a small sleepy little town on the north coast that had an unusually high "missing persons" rate. Conveniently dubbed as the "Murder Capital of the World," the city of Santa Carla was home to dozens of bloodthirsty, demonic vampires of the night who wreaked havoc on its unsuspecting inhabitants.

The blockbuster film called *The Lost Boys*—starring Jason Patrick, Kiefer Sutherland, Jami Gertz, Corey Haim and Corey Feldman—was filmed in downtown Santa Cruz at the famed Beach Boardwalk. The Gothic cult vampire film became an overnight sensation. As it turns out, the nightmare depicted in the sensational film is not far from the truth. Santa Cruz history harbors its own evil demons that have left permanent scars on the city's history.

In 1973, at a local press conference, District Attorney Peter Chang inadvertently dubbed Santa Cruz as the "Murder Capital of the World," and with good reason. As the body counts piled up of men, women and children who were either missing or found murdered throughout the small county of Santa Cruz, law officials were left with few leads and even fewer answers. The fear within the community was nothing to be taken lightly. Between 1970 and 1973, more than twenty-five vicious murders occurred in Santa Cruz County. Santa Cruz was the hunting grounds for not one but three of history's most notorious serial killers.

On October 19, 1970, a twenty-four-year-old, acid-dropping, hippie environmentalist named John Linley Frazier set out on a quest to rid the

Santa Cruz Beach Boardwalk was once known as the fictional city of "Santa Carla." *Courtesy of Library of Congress.*

world of what he thought was a wasteful materialistic society. Frazier, an admirer of Charles Manson's, swore his allegiance to do God's work and save the planet. His first vexation: forty-five-year-old Japanese eye doctor Victor M. Ohta.

Dr. Ohta was a flashy and well-to-do yet likeable physician who was well respected in the community and had what some may call a "rags to riches" story. Living on a secluded hilltop in a luxurious mansion in the small town of Soquel in Santa Cruz County, Ohta spared no expense so he and his family could enjoy a luxurious lifestyle, even going as far as to bulldoze a hillside, removing many trees from the natural landscape, for an additional driveway.

Meanwhile, nature-loving hippie neighbor John Linley Frazier, who squatted in a mountainous six- by six-foot shack nearly half a mile away, grew increasingly unhinged as he secretly spied on the Ohta family. He fixated his wrath on what he believed to be a gluttonous/materialistic nature of cataclysmic proportion. Frazier informed his fellow hippie-loving groupies that "big things were going to happen, come Monday."

On October 19, John Linley Frazier entered the Ohta residence and waited for the family to return home, one by one. As each family member returned, Frazier tied their hands behind their backs with colorful silk

scarves he found in the home—five people in total: Dr. Ohta; his forty-three-year-old wife, Virginia; their two sons, Derrick (twelve) and Taggart (eleven); and Ohta's thirty-eight-year-old secretary, Dorothy Cadwallader, a married mother of two.

Frazier shot and killed each of them, execution style, and threw their lifeless bodies into the swimming pool. He even shot their cat. Frazier then set the beautiful mansion on fire. It wasn't until firemen arrived to put the inferno out that they discovered the grisly scene that lay before them. Police later found a note left on the doctor's Rolls-Royce: "Today World War 3 will begin as brought to you by the people of the free universe. From this day forward, anyone or company of persons who misuses the natural environment or destroys same will suffer the penalty of death by the people of the free universe. I and my comrades from this day forth will fight until death or freedom against any single anyone who does not support natural life on this planet materialism must die or mankind will."

Police feared the rise of a new Manson cult and that this was only the beginning of what was yet to come. Fortunately for the people of Santa Cruz, their fears were laid to rest when police apprehended Frazier three days after the horrific murders were discovered. Several hours after the murders were publicly disclosed, an anonymous tip to police authorities implicated Frazier, who on more than one occasion stated to his hippie comrades that "Ohta should be snuffed out for his materialism!" Frazier was ultimately found guilty of capital murder and sentenced to the gas chamber. Fortunately for Frazier, soon after his sentence capital punishment was abolished in California, and his sentence was commuted to life in prison. On August 13, 2009, John Linley Frazier committed suicide by hanging at Mule Creek State Penitentiary in Ione, California. He was sixty-two years of age.

As chilling as the Ohta murders were, more death was soon to follow the small, seemingly cursed city of Santa Cruz. Edmund Emil Kemper, who became known as the "Co-ed Butcher" or the "Co-ed Killer," ravaged the city of Santa Cruz between 1972 and 1973. He killed six young UCSC women before killing his own mother and her best friend in their Aptos home.

Edmund Kemper's rage began in 1964 at the age of fifteen while he resided with his grandparents Maude and Edmund Sr. in North Fork, California. Kemper, who stood a staggering six feet, four inches tall, was estranged from his biological father, had a back-and-forth relationship with his mother, Clarnell Strandberg Kemper, and demonstrated early signs of mental and emotional instability. He had already began fantasizing about death and murder at an early age. He ultimately acted on these fantasies.

In the early morning hours of August 27, 1964, Edmund Kemper shot and killed his grandmother in a psychotic rage while she sat at the kitchen table working on her children's novel. He hated his grandmother. She was domineering like his mother, and she easily infuriated him. The teenage Kemper, fascinated by what he had done, simply watched as his grandmother lay dying. As the blood pooled from her body, he sat idly, doing nothing to assist her and watching as the life left her eyes.

After reality set in and he realized what he had done, Kemper feared how furious his grandfather would be and decided that he had only one recourse: his grandfather must also die. It was only a matter of time before his grandfather would return home from the grocery store and discover what he had done. When Kemper's grandfather arrived home from the store with a bag of groceries in hand, the teenager charged from the house with a .22-caliber handgun and shot the elderly man before he had a chance to shut the car door. He was instantly killed.

In a fit of desperation, young Edmund called his mother, informing her of what he had done. She convinced him to call the police. Disturbingly, Edmund's mother was not shocked by the carnage her son had bestowed on his own grandparents. In fact, as a child, young Kemper abused animals and played with their rotting corpses, posing them as trophies in the bedroom closet of his mother's Aptos home.

Edmund's mother, Clarnell Strandberg Kemper, was well aware of her son's strange behavior, but this only strengthened her abusive nature toward him. She constantly belittled him, humiliated him and blamed him for his father leaving her. Clarnell was a very controlling and domineering woman. She had forced Edmund to sleep in the basement of their home when he was an eight-year-old child. One can only imagine the fear of any youngster being forced to sleep in a cold basement, and one can only envision the fearful cries he made that fell on a cruel mother's deaf ears.

Edmund's mother was said to have gone as far as to place a padlock on the trapdoor to the basement leading to young Edmund's dark, dungeon-like room beneath the kitchen floor. Edmund's mother feared her young son at the age of eight and claimed that he had intentions of raping his sister. It is also believed that Kemper's mother likely had the onset of a borderline personality disorder or other mental illness that caused her wicked ways. To a child living with her madness, she would have seemed evil.

After Edmund murdered his grandparents, he was sent to Atascadero State Mental Facility, where he served fewer than five years. During his stay at the facility, Kemper's IQ level registered off the charts, putting many scholars

to shame. With his exceptional intelligence, he was able to manipulate his doctors and facility staff, gaining their trust and even gaining access to test results, allowing him to memorize answers and manipulate the outcome of psychological tests.

Eventually, Kemper was able to convince his physicians, attorneys and state officials that he was stable enough to reenter society. Kemper was released in 1969 into his mother's custody at her Aptos home. Kemper's juvenile record was sealed.

December 18, 1969, was Kemper's twenty-first birthday. Now standing at six feet, nine inches and more than 250 pounds, Kemper, known as "Big Ed," was a free man. However, between 1972 and 1973, Kemper's mental state began to deteriorate once again. The demands of Kemper's controlling and abusive mother had taken their toll, and once again, Kemper snapped. His inability to have relationships with the opposite sex and failure to follow his dreams of becoming a police officer added to his frustration.

Kemper's mother worked at the University of California–Santa Cruz as an administrative assistant. Her son grew angry with her, as she not only prevented him from finding a girlfriend at the local university but also constantly belittled him, making him feel unworthy of love and criticizing his manhood while she continued to make demands of him around their Aptos home. Kemper resented his mother for her abusive nature, and as a result, his resentment manifested into hatred for the opposite sex.

As a result, Kemper snapped, and he began his murderous rampage of what would ultimately be six local college women. However, in 1972, while police were trying to find missing young college students, another series of grisly homicides surfaced in the area. At the same time, and unbeknownst to local police authorities, a second serial killer was roaming the streets of Santa Cruz. It was none other than Felton resident Herbert William Mullin.

Like Kemper, Mullin was a child prodigy. He was voted "Most Likely to Succeed" by his high school classmates, but by the age of twenty-five, Mullin was an acid-popping occultist who believed that he alone could prevent an imminent earthquake from destroying California by performing human sacrifices. While Mullin was on a murderous spree of his own that involved thirteen victims, including a Catholic priest in his confessional, Edmund Kemper was hanging out at a Santa Cruz pub known as the Jury Room, a local drinking hot spot for off-duty law enforcement. Kemper, affectionately known as "Big Ed" to the local law, had openly befriended police and detectives alike. After a few mixed drinks and establishing

camaraderie with the local fuzz, Kemper was able to get the inside scoop of the ongoing homicide cases firsthand. He even provided them with insight, helping them deduce that the case was more likely the work of two serial killers as opposed to one.

While the police commenced on a nearly two-year-long wild goose chase, the death toll rose. The only solace given to the city of Santa Cruz was from a witness who saw Mullin kill his final victim and came forward with the information. Mullin was apprehended a few days later. Meanwhile, after brutally killing and dismembering several UCSC coeds, Kemper decided to end his murderous reign and destroy that which he hated most. On Good Friday of April 1973, Kemper saved his very own mother for last.

Finally fed up with his mother's endless ridicule and belligerent behavior toward him, Kemper beat her in the head with a claw hammer while she slept. After she was dead, he cut off her head, had oral copulation with it and placed it on the mantel above the fireplace, where he tauntingly threw darts at her face.

But that wasn't the end of Kemper's expression of maternal bonding between him and his mother. Lastly, he removed his mother's vocal chords and placed them in the kitchen garbage disposal, claiming that this was a

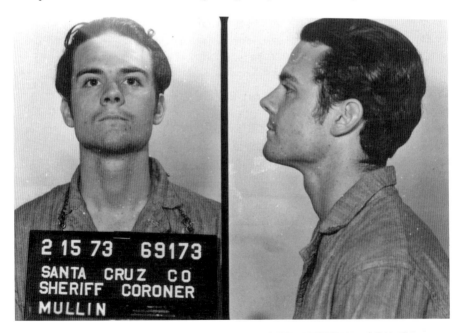

Henry Mullin's mug shot, Santa Cruz County, 1973. *Courtesy of the County of Santa Cruz.*

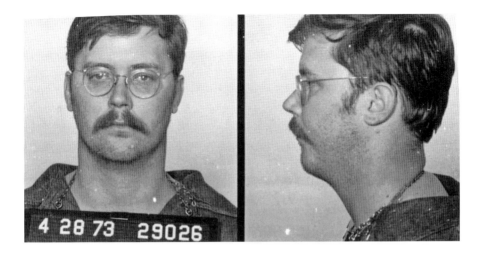

Above: Edmund Kemper's mug shot, Santa Cruz County, 1973. *Courtesy of the County of Santa Cruz.*

Right: Crime scene photo of the Herbert Mullin killings, Santa Cruz, California. *Photo by Sam Vestal, courtesy of the Vestal family collection.*

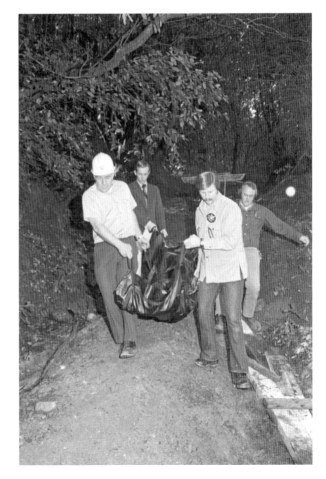

fitting end to her "constant bitching." Kemper still did not stop there. Next, he called his mother's best friend, Sally Hallett, and invited her to dine with him and his mother.

Upon her arrival, Kemper violently punched Hallett as she entered the home, knocking the wind out of her. He then proceeded to strangle her to death. Kemper subsequently left the Aptos home and began driving, with plans to flee the state. However, he eventually ended up calling authorities and turned himself in without incident.

Santa Cruz residents were finally able to breathe a sigh of relief and mourn the many lives stolen by these demons. The same could not be said of the two beasts, Mullin and Kemper, sitting in their jail cells. At Santa Cruz County jail, both men were housed in the same cell, where the two ironically did nothing more but argue, each accusing the other of stealing locations that were used to dump their victims. The feud between the two grew so boisterous that guards were forced to separate the two.

So the next time you happen to watch the movie *The Lost Boys*, about a nightmarish little town by the sea once known for being the "Murder Capital of the World" and filled with vampires, just remember that bloodthirsty creatures aren't always what they seem. Nightmares really do exist.

JOHN LINLEY FRAZIER VICTIMS

Dr. Victor Ohta, forty-five, October 19, 1970
Virginia Ohta, forty-three, October 19, 1972
Derrick Ohta, twelve, October 19, 1972
Taggart Ohta, eleven, October 19, 1972
Dorothy Cadwallader, thirty-eight, October 19, 1972

HERBERT WILLIAM MULLIN'S VICTIMS

Lawrence White, fifty-five, October 13, 1972.
Mary Guilfoyle, twenty-four, October 24, 1972.
Father Henri Tomei, sixty-five, November 2, 1972.
Jim Ralph Gianera, twenty-five, January 25, 1973.
Joan Gianera, twenty-one, January 25, 1973.

Kathy Francis, twenty-nine, January 25, 1973.
Daemon Francis, four, January 25, 1973.
David Hughes, nine, January 25, 1973.
David Allan Oliker, eighteen, February 6, 1973.
Robert Michael Spector, eighteen, February 6, 1973.
Brian Scott Card, nineteen, February 6, 1973.
Mark John Dreibelbis, fifteen, February 6, 1973.
Fred Perez, seventy-two, February 13, 1973.

EDMUND E. KEMPER'S VICTIMS

Edmund E. Kemper Sr., August 27, 1964
Maude Matilda Hughey Kemper, August 27, 1964
Mary Ann Pesce, eighteen, May 7, 1972.
Anita Luchessa, eighteen, May 7, 1972
Aiko Koo, fifteen, September 14, 1972
Cindy Schall, nineteen, January 7, 1973
Rosalind Thorpe, twenty-four, February 5, 1973
Alice Liu, twenty-three, February 5, 1973
Clarnell Strandberg Kempter, April 20, 1973
Sally Hallett, fifty-nine, April 20, 1973

GHOSTS OF GOLDEN GATE VILLA

Just a few houses down from the former McCray Hotel stands the magnificent Golden Gate Villa. Built in 1891, this Queen Anne–style historical landmark is nicknamed the "crown jewel of Santa Cruz." This plush relic in its heyday was frequented by high-society bluebloods, socialites and politicians, including regulars such as President Theodore Roosevelt and famed inventor Thomas Edison. However, despite the lavish architecture and the noble guests it once housed, this grand mansion harbors a sinister tale.

Built in 1891, the villa was home to Major Frank McLaughlin, his wife, Margaret, and her daughter, Agnes. Throughout the decades, the McLaughlins hosted grand parties to society's elite. The mansion's custom furnishings and lavish décor represented a status symbol of influence and wealth.

The Major, as he was best known from his militant past, was a lifelong friend of inventor Thomas Edison. He was also a zealous investor and ingenious mining engineer, best known for the development of the California gold fields along the Feather River of Butte County, Oroville. Oroville, known as "Gold City," was a seemingly smart choice to prospect. By 1892, with McLaughlin's engineering background, he had begun construction of one of the most recognized accomplishments in the West: a great stone retaining wall, more than seven thousand feet in length and said to resemble the Great Wall of China. A dam was built along the Feather River, diverting the river to flow through a canal on the other side. The wall was so magnificent that it was

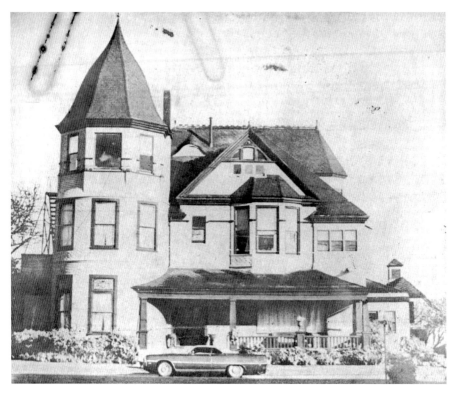

The Golden Gate Villa, Santa Cruz, California. *Courtesy of the Santa Cruz Museum of Art and History.*

inspected by engineers from around the globe. His good friend Thomas Edison introduced the first electric light bulb to the vast construction site, allowing for the project's more than one thousand laborers to work day in and day out on the vast development. With investment capital flowing from across the seas by the millions by those wanting a piece of the action and lofty prospects of gold from the West for all, the Major's endeavors seemed endlessly fruitful.

A return of at least $100 million was expected on what was only a $12 million investment. However, the great operation collapsed into bankruptcy one year after it was completed. After mining crews began excavating the empty riverbed, anticipating to find mounds of gold, their prospects sank when they unearthed nothing more than old rusted picks and buckets. The riverbed had already been mined more than half a century earlier. It appeared that McLaughlin had enemies in the Oroville area who already knew his efforts would be fruitless and wanted his failure to be

memorialized—retribution for all the gold he had already dredged off the land and flaunted in their faces. McLaughlin, insulted and enraged by the townspeople's betrayal, lined the great wall with dynamite and blew it up.

The failed Oroville expedition seemed to set off a chain of events for McLaughlin that left a dark shadow that seemingly followed him for years to come. On November 16, 1905, a dark day hit the McLaughlin home as the Major's beloved wife of thirty years was called on by the angel of death, as reported by the *Santa Cruz Sentinel* the next day:

> *DEATH OF MRS. M'LAUGLIN*
> *Beloved Wife of Major Mclaughlin Passes Out Late Thursday Evening*
>
> *Death came to relieve the sufferings of Mrs. Margaret McLaughlin, wife of Major McLaughlin, at their home in this city at five minutes past eleven on Thursday night. Mrs. McLaughlin's death was due to liver troubles and a general debility, which she had been suffering from for a year past. She had been confined to her bed for the past six weeks, and had been attended by Dr. Morgan and Dr. Farnum of San Francisco, who both did everything that could be done, but to no avail.*
>
> *Major McLaughlin and their daughter Agnes are heartbroken over their loss, which will be felt keenly by many friends in this city outside the family circle. The body will be taken east, for interment in the family burial plot in Newark, N.J., in which city Mrs. McLaughlin was born.*
>
> *Deceased was a lady of most estimable qualities and the devotion of herself and her husband was a marked characteristic of their life. She was the daughter of Hugh McDonald, a well-known contractor of Newark, N.J., and was married to Mr. McLaughlin thirty years ago. They lived in New York City for some years, coming to California in 1879, and to Santa Cruz in 1889. They had one daughter, Agnes, who, with her father, will have the sympathy of a large number of sincere friends in this city and county.*

The passing of the Major's wife was a huge blow to him and daughter Agnes. Although both knew that Margaret's illness was grave and that death was imminent, the loss was nevertheless profound, especially for the Major, whose life partner of thirty years was no longer present in the home that they had lovingly built together.

Emptiness filled his heart, a void that could only seemingly be replenished by the love and companionship of his then thirty-two-year-old daughter, Agnes. Agnes was the apple of the Major's eye after he had married

Margaret, a widow, and met young Agnes, who was believed to be four years of age at the time. The Major legally adopted Agnes, as he and his wife, for unknown reasons, seemingly never had children of their own.

The Major loved Agnes, and from childhood to adulthood there wasn't a thing that the Major did not provide for her. Despite being the envy of high-society socialites, Agnes was atypical and unusual. A devote Catholic who frequently attended mass at Holy Cross Church, the attractive thirty-two-year-old Agnes was somewhat of a recluse and did not have many suitors who expressed interest in courting her. At the age of thirty-two, most if not all of Agnes's classmates from school were married with children or already on a second marriage. But not Agnes. She continued to reside in the mansion, her bedroom located in the upper tower of the Villa, with servants to aid her every summons.

Agnes often traveled with her father on various vacation retreats or, at times, long-distance business meetings. The Major adored her like no other and had a beautiful stained-glass window hand-crafted in her likeness and displayed in the framework of the Golden Gate Villa for all to see.

After the death of his wife, the Major continued on with different business ventures, frequently traveling to and from San Francisco, visiting with familiar faces and associating with persons in his privileged circle. However, tragedy struck again five short months after losing his beloved Margaret. On April 18, 1906, at 5:12 a.m., an earthquake with a magnitude of 7.8 shook the California northern coast, leaving a chain of destruction in its wake. From the busy city streets of San Francisco to the sleepy hollows of Santa Cruz, buildings crumbled and fires burned as the San Andreas Fault awoke in a raging fury.

While the destruction in Santa Cruz was substantial, there was no loss of life, unlike the near obliteration of its sister city, San Francisco, home to many loved ones of Santa Cruz citizens. The death toll reached upward to three thousand people, and 80 percent of the city was completely destroyed, leaving behind a smoldering inferno.

After the devastating earthquake devoured the city of San Francisco and Santa Cruz was safely rebuilding, the Major began focusing his efforts and utilizing his engineering expertise to help reconstruct the wreckage of what once was the city of San Francisco. However, nothing could prepare him for the undertaking at hand. With the death toll in the thousands and his personal ties to the wealthy and elite in the San Francisco area, the Major witnessed firsthand the suffering of those whom he had taken for granted, both financially as well as personally, and the monetary ruin that they were all destined to endure.

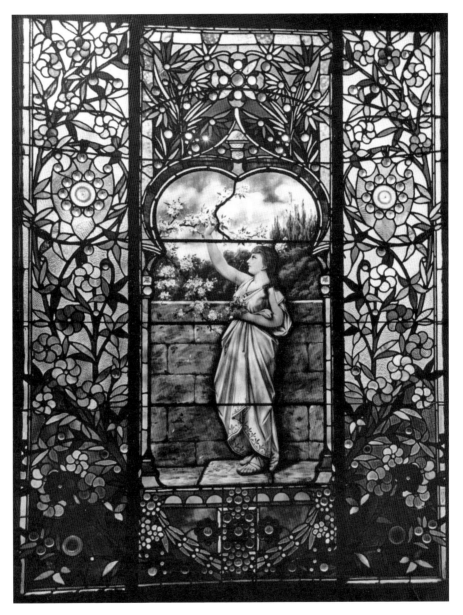

Stained-glass window designed in the likeness of daughter Agnes McLaughlin. The paintbrush bristles used in its creation were made from actual hair of Agnes McLaughlin. *Courtesy of Santa Cruz Museum of Art and History.*

As both cities carried on to rebuild, news spread that Ms. Agnes McLaughlin was to give her hand in marriage to a handsome, well-to-do suitor who frequented their inner circle. Sadly, this blissful tale of matrimony would never transpire past idle chitchat, as tragedy soon struck the McLaughlin household once again.

Miss Agnes continued to frequently travel with her father during the summer months of 1907 and host many dinner parties at their Santa Cruz villa catering to nothing less but the upper class. However, this year there was something amiss with the Major, and as the seasons changed from fall to winter, Ms. Agnes began to notice subtle changes in her father's demeanor. The Major began to withdraw from the limelight and was spending hours on end wallowing in his library alone.

He distanced himself from his beloved Agnes, and she frequently observed him mumbling to himself in an irrational manor, pacing the halls back and forth perplexed and distraught. Agnes assumed that her father was going through a bad spell that would soon pass. She was completely unaware of the madness that was truly consuming the Major's tortured mind.

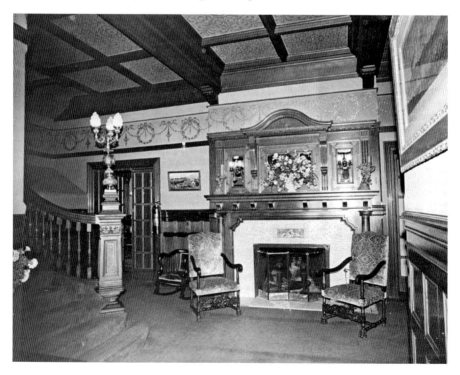

The Golden Gate Villa's entry hall leading to Major McLaughlin's library. *Courtesy of Santa Cruz Museum of Art and History.*

As time passed, the Major's behavior grew increasingly dark. He spent hours furiously writing letters in his library. The hired help would occasionally listen by the double doors, as they heard what sounded like sobbing from within the confines of his solitude. He seemed possessed by a looming madness.

November 16, 1907, was the two-year anniversary of the death of Agnes's mother, Margaret. Agnes dressed in fanciful church attire and arrived in a pristine horse and buggy in honor of the occasion. The coachman politely held the door open, as her consort respectfully awaited to take her hand as she exited the cab. Chaperoned to the grand entrance of the Holy Cross Church on Mission Hill, Agnes went inside. She would pay homage to her mother at a church vigil dedicated to her remembrance. As the parishioners sang to the heavens and the organist played her angelic hymns, Agnes took heed to remember her father in her prayerful thoughts, a prayer that would go unanswered. As the clock struck noon, the church bells sounded off, echoing for the entire town to hear; the mass had ended.

Agnes retreated back home to the Golden Gate mansion, where she dined on a lavish late lunch before retiring to her high-towered noble abode. Removing her dress and corset, Ms. Agnes lay on her plush white bedding, anticipating a restful afternoon slumber. As Agnes slept, the Major continued to wallow in his library, consumed with thoughts of guilt, self-pity and retribution on the anniversary of his wife's death. His madness devoured what sanity he had left, and the Major's actions have been questioned by historians ever since.

The Major, taking one more shot of brandy, neatly assembled several envelopes on his desk, named to specific individuals. He loaded his .44-caliber pistol. Certain that the servants were not on the premises, he staggered his way up to the second-story level of the mansion, where he entered Agnes's room. There he watched as she slept, peaceful and unaware of her impending eternal slumber. With tears in his eyes, the Major cocked back the hammer, placed the barrel of the gun to her temple and pulled the trigger. Agnes would never wake again. "We will all be together soon," the Major whispered.

The Major made his way back to his bedroom, where he filled his glass of brandy, pulled a bottle of potassium cyanide out of his desk drawer and drank the contents of the bottle. The Major then called former lieutenant governor Jeter, one of his most intimate friends. He begged Jeter to come to his house immediately. The following details from the November 17, 1907 *San Francisco Chronicle Sun* set the scene:

"You must come…I have just killed my daughter Agnes and I have taken poison. I will be dead before you get here."

Jetter tried to reply, but the telephone receiver was hung up with a snap. He rushed into the street, where he found, C.E Lilly, seated in an automobile. The pair raced to Golden Gate Villa the home of Mclaughlin. When they arrived the Major lay dead on a couch in his bedroom. His daughter Agnes was laying on her bed in a dying condition a bullet having crashed through her brain.

As police, the coroner and an ambulance clambered up to the Golden Gate Villa to assess the situation, they found poor Agnes bleeding profusely from the head, still hanging on to life. She would succumb to her injuries hours later. Investigators pored over letters found in the Major's library that implied that his acts were premeditated—the work of a man whose thoughts were filled with confusion. In a released letter to the *Santa Cruz Evening News* dated December 7, 1907, the public finally learned the motive behind the madness:

MCLAUGHLIN SHOT AND KILLED HIS DAUGHTER, AND POISONED HIMSELF ON SATURDAY NOV. 16TH, AT HIS BEACH HILL HOME. HE WROTE HIS LAST WILL ON THE TUESDAY PRECEDING. THE DOCUMENT, PERHAPS THE MOST REMARKABLE TESTAMENT EVER FILED IN A CALIFORNIA COURT FOLLOWS IN FULL. IT SUPPLIES MCLAUGHLIN'S DEFENSE FOR HIS ACT IN TAKING HIS DAUGHTER'S LIFE AND HIS OWN:

Hon. W.T. Jetter, Santa Cruz, Cal:
"My dear, kind, patient, generous friend, may God bless you and you're for your constant kindness to me. This is an ungrateful return for all your friendship, but I CANNOT help it. I have lived in such a sea of trouble so long that at last I see madness ahead of me if I don't leave this weary world of trouble. To leave my darling child, helpless and penniless, would be unnatural, and so I take her with me to our loved one. She is the very last one who could face this world alone. Hers would be one long longing for our dear one and myself. I have shielded her, as I did my dearest wife, from ALL knowledge of my poverty, my losses, my shifts, and have laughed at any idea of poverty of distress. You are the only one who knows my true condition. Only God Himself knows how I have kept up and smiled to the world."

As the investigation progressed and details were revealed in the Major's writings, the small community of Santa Cruz had difficulty understanding the Major's motives. McLaughlin bequeathed an abundance of valuables

in his last will and testament to a small circle of friends, including his loyal house servants. Even though there was a mortgage on the Golden Gate Villa, the remaining McLaughlin fortune, although meager, was still enough to make ends meet or at least enough for his daughter, Agnes, to sustain herself. So the questioned remained: why kill Agnes, a woman who was engaged to marry a well-to-do former mayor?

Questions surrounding the man and his motives went unanswered, and to this day, they continue to be shrouded in mystery. Was he truly concerned about money? Was he riddled with grief for the loss of his beloved Margaret? Could it be that he was actually in love with his daughter, Agnes, and could not stand the thought of her marrying another? Or was he completely mad?

The bodies of both Agnes and the Major were assembled at the Holy Cross Church for a public remembrance and then again collected and housed at the Golden Gate Villa for a private ceremony of about fifty friends and family. The villa was adorned with flowers, candles, crosses and wreathes in celebration of their lives. Afterward, they were transported and shipped to Newark, New Jersey, where together with the body of mother and wife Margaret McLaughlin, the three were laid together in eternal rest.

It would be many years before the Golden Gate Villa would find a new master to care for its vacant halls. Those who dared speak of it would utter rumors of the great mansion and dark tales of what happened there. The many stories of the mansion being haunted with the spirits of the McLaughlin family would circulate for years to come stories that have made the Golden Gate Villa legendary.

The villa would house several new owners until finally landing a committed one by the name of Patricia Wilder. Coincidentally, Wilder purchased the twenty-two-room, ten-thousand-square-foot mansion located at 924 Third Street on November 17, the anniversary of the infamous murder-suicide.

In a 1982 interview from the *Santa Cruz Sentinel*, Wilder noted:

> *"He didn't want to have his daughter have to face poverty," says Wilder, one of seven owners of the home.*
>
> *But ghosts? Well, Wilder prefers to call it an "essence."*
>
> *For example, Wilder says she bought the house on November 17, 1968—the same date as when McLaughlin killed himself. And she was surprised to learn the colors she decided to repaint the house were those which it had originally been painted.*
>
> *"There's an essence here, though not in the sense of seeing someone" she says. "I've often had the feeling someone was watching."*

"There is a spirit force in the house, but it's nothing evil."
McLaughlin had a motto for his house which is inscribed in calligraphy
and displayed prominently in the front hall. It reads:

"He who enters here leaves all cares behind."

An essence or a spirit force in the house? Ms. Patricia Wilder, born on October 31, 1924, passed away in 2014 at the honorable age of eighty-nine. The love of her life was the Golden Gate Villa. Since her death, the villa has once again been sold and now currently serves as rental units. A current tenant of the villa, D. Cebold, shared her experiences in 2016:

> *I reside in Agnes's old room in the tower. There is definitely something here!*
> *I opened the curtains to let in some light and suddenly they pulled closed all*
> *by themselves. I have seen chairs that were intentionally moved down stairs*
> *in front of the fireplace only to come back and see them moved in a different*
> *spot while no one else was in the house.*
>
> *Strange things occur in the closet in my room—one minute my clothes*
> *are hanging on the bar in the closet and the next they have been thrown all*
> *over the floor.*
>
> *My friends have had experiences as well, and even a male friend refused*
> *to come back. Others are fearful to talk about their experiences. I guess they*
> *don't want to sound crazy.*
>
> *One day I fell into a deep depression and even contemplated suicide, and*
> *then I felt as if a female was standing near me, telling me not to, that I had*
> *a life to live for, unlike the life she had stolen from her.—I believe it was*
> *Agnes. I think she protects me, but I don't think she likes men much.*

Does Agnes still wander the halls of the Golden Gate Villa, warding off male spectators whom she feels may cause harm as she continues to relive her untimely death? Or perhaps the Major continues to wander, trapped in his own dominion of dark, foreboding guilt, thrusting open curtains and demanding to see the light that his restless spirit unwittingly yearns for but can never find. Or perchance it's still yet the restive soul of Margaret, loving wife of the Major and devoted mother to Agnes, who eternally watches over the grand mansion, vigilantly trying to protect all those who enter from a harm she was unable to avert, as she continues in her endless search of the souls of her beloveds.

"He who enters here leaves all cares behind…"

EVERGREEN CEMETERY

Established in 1850, Evergreen Cemetery is the oldest known Protestant Cemetery in Santa Cruz County. The final resting place to many of Santa Cruz first pioneers, Evergreen is believed to be one of the most actively haunted cemeteries in the county.

The cemetery is said to have an estimated 2,000 deceased buried at the small site, including more than 120 children who died as a result of disease or accidental death. The spirits of these children have been felt by the many volunteers from the Santa Cruz Museum of Art and History, commonly known as MAH. Dating back to as early as 1908, and thanks to the efforts of DeEtte Newcomb, for more than 100 years volunteers have tirelessly ventured to the cemetery in a continuous effort to restore and maintain the nearly 170-year-old haven for the dead so that future generations may enjoy its parklike setting and the historical value it provides the community.

However, volunteers are not the only visitors of Evergreen who claim to encounter the playful spirits of childlike behavior. Homeless persons, who often hide in the woods above the grave markers, ironically left after the spooks and specters seemingly began to invade their camps, frightening off the new would-be tenants. According to a MAH volunteer, one woman who had frequented the cemetery would often hear a bell ring and the sound of a child singing. She would often sing back to the unseen entity and leave toys among a patch of headstones where children were known to be buried.

The spirits of children are not the only apparitions rumored to haunt this historic homestead. It is claimed that a legendary prostitute known as Marie

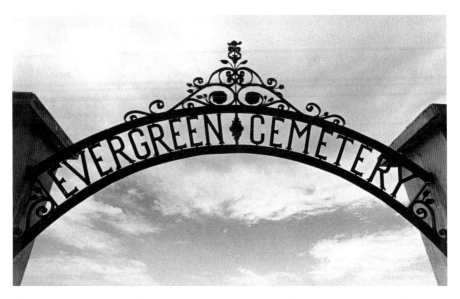

Evergreen Cemetery, established in 1850. *Courtesy of Santa Cruz Museum of Art and History.*

Holmes wanders its woods. According to an 1898 article in the *Santa Cruz Evening Sentinel*, the young woman took her own life in despair:

> *MARIE HOLMES' END.*
> *SHE SWALLOWS A FATAL DOES OF CARBOLIC ACID*
> *The Woman Committed Suicide While Despondent—Frequently Threatened to Do So.*
>
> *Marie Holmes, who was an inmate of a house of ill repute on Pacific Ave committed suicide at 9:30 o'clock Thursday evening by swallowing a large dose of carbolic acid on Mission near River St. After she had taken the fatal dose she threw the bottle away and walked down Pacific Av. Until in front of Merrill Bros' saloon, where J.M. Merrill, who was standing at the entrance saw her stagger She asked Mr. Merrill to assist her, as she was about to fall. He asked her what the matter was, and she told him she had taken carbolic acid to kill herself.*
>
> *The woman was taken to S.A. Palmers drug store and medical aid summoned. Although everything possible was done to prolong life it was of no avail, for the dose the woman had taken had proven fatal. She died in fifteen minutes after assistance reached her.*

The remains were taken to Wessendorf & Stafflers undertaking parlors. The deceased came to Santa Cruz about six months ago from Watsonville. She was suffering from consumption and was of a melancholy disposition. Those who knew her were not surprised at her committing suicide for she had frequently threatened to do so. A month ago she wrote to a friend of her intention to end her life, and giving directions as to the disposition of her body. Just as she was about to put her threat into execution the pistol was taken away from her. While in Salinas before she went to Watsonville, she also threatened to end her life.

On Thursday afternoon she went to the beach with a friend named Gladys Mills, and inquired where the deep water was. He companion, who suspected that the woman was then thinking of suicide, induced her to return to her room. Later in the evening the deceased made an engagement to meet a friend in a restaurant at 11 o'clock to have supper. At 9 o'clock the deceased told Frank Towne that she wanted to engage his hack to take her to the depot for the 6:45 train this morning. As she left Towne she gave him a pink Scon, afterward she took the deadly dose.

In the afternoon she was noticed to be crying. She said she had no friends and was alone in the world. She shed bitter tears of anguish as she regretted she was unable to lead a better life. To her the future looked dark, for she saw no way to break the bonds of sin which held her in a vice-like grip. The woman resolved to end it all by taking a fatal plunge into oblivion.

She was a native of England, aged about 20 years. None of her friends knew anything about her relatives or what her real name is. All they knew of her was that she had a child, but they do not know where the child is. The Coroner will hold an inquest.

Marie Holmes was buried at Evergreen Cemetery a few days later, the expenses of the funeral paid for by friends of ill repute. There was a choir, floral arrangements and the shedding of tears among friends. Marie Holmes, who felt she had nothing to live for, touched the lives of those who would remember her and left a legend that is still related nearly 120 years after her death. Many believe that they have seen a glimpse of the solid apparition of Marie Holmes standing near her headstone, while others firmly believe that her spirit was freed from despair on the day of her funeral, liberated by the love of her friends, who truly showed that they cared.

In addition to the many pioneers whose remains are laid to rest here, there are many of the founding families of Santa Cruz, including that of

Louden "London" Nelson, a black man from North Carolina who was born into slavery and later bought his freedom. After doing so, Nelson settled in Santa Cruz County in 1856. He worked as a cobbler and purchased land, becoming a farmer. Nelson had a love for children and education, despite the fact that he himself did not know how to read or write. Nelson had always wished to learn, and before his death in 1860, he made an oral will bequeathing all of his worldly possessions to the local school district, which recently had been forced to close its doors due to lack of funding. Because of his donation, a new school was erected on Mission Hill, Holy Cross, and education continued. The Louden Nelson Center, a civic auditorium in Santa Cruz, was named in his honor.

Another colorful character buried in Evergreen Cemetery is Judge William Blackburn, who presided over Santa Cruz as one of its first county courthouse judges, beginning in 1847. Judge Blackburn was known for his unprecedented but effective means of public justice. In one of his court cases, a native Californian sheared off all the hairs of the mane and tail of his horse to spite another of his countrymen, a great injury and insult to the man, and the case was brought before Judge Blackburn for settlement. After careful consideration, the judge could not find any law bearing on the case other than the old Mosaic law, which promotes "an eye for an eye—a tooth for a tooth." "Take the culprit and have his mane and tail shaved," was the judge's decision. The native inhabitants approved this decision, and the sentence was immediately carried out on the steps of the courthouse. The man was stripped of all of his clothing and shaved of every hair from his body, from the top of his head to the soles of his feet. Justice was served.

In another court case presided over by Judge Blackburn, a local resident filed suit for damages. A pig had wandered into a citizen's kitchen garden, so the garden owner shot the pig dead. After, a thief stole the dead pig from the garden owner. The owner of the pig brought suit against the citizen who shot the pig. Once again, there was no law that the judge could reference. So he determined in fairness that the individual who stole the dead pig from the garden owner was to blame and needed to be apprehended and brought before the court to pay restitution for the pig and all of the court costs absorbed by the garden owner who shot the animal dead and the man who owned the pig.

Despite the colorful characters who sleep everlasting at Evergreen, there are a few who are still restless. Such is the case of a famed Evergreen Cemetery specter claimed to be seen as a dark, shadowy figure near the

treetops of Evergreen Cemetery. It is none other than Andrew Jack "A.J." Sloan, also known as the "Ghost of Arana Gulch."

Sloan was riding alongside his friend by the name of Towne on horseback toward his nearby homestead. When the two men went through Arana Gulch, through a small creek bed and under a bridge, there they encountered three caballeros by the name of Faustino Lorenzano, Pedro Lorenzano and Joe Rodriguez. The banditos shot Sloan three times. One bullet struck Sloan in the arm, the other in his side and the final shot in his leg, which is said to have severed an artery. Pedro and Joe were believed to be between eighteen and nineteen years of age. It would appear that the three were lying in wait to assassinate Jose Arana when Sloan and Towne approached on horseback. Suspicious of the men who were crouching behind the bushes, Sloan, a no-nonsense cowboy of his time, confronted the men, and an altercation ensued, leading to gunfire. A.J. Sloan is said to have died on scene, and his remains were buried at Evergreen Cemetery in 1865.

Thirty years after the death of Sloan, a woman and her daughter reported seeing the apparition of something believed to be Andrew Jack Sloan's spirit wandering through Arana Gulch. Here is the excerpt from that *Santa Cruz Sentinel* article from 1895:

SAW AN APPARITION

Strange Sight Witnessed by a Mother and Daughter at Arana Gulch Murder of Jack Sloan in 1865 Recalled—Something for Psychologists to Investigate—

A strange story was told by a lady who resides on the Soquel road in Mathews & Tuttle's office this week. She believes what she saw, and as to whether it was possible or not we leave to those fond of investigating psychological subjects.

The lady said that she and her daughter were driving towards this city the other day during the forenoon. When at Arana Gulch she saw the apparition of a man walking across the road, and then disappeared. She called the attention of her daughter to the apparition, which she plainly saw. It disappeared as mysteriously as though the earth has swallowed it.

The mother and daughter were startled and were pale with excitement. They told what they had seen to Thomas A. Sweeney, who from the

Cloud Family Plot, Evergreen Cemetery. *Courtesy of Santa Cruz Museum of Art and History.*

description recognized the form of Jack Sloan, who was killed at Arana Gulch in 1865. Mr. Sweeney was a member of the Coroner's jury which investigated the murder.

Sloan and his brother in law, J.W. Towne, were riding on horseback one night through the gulch, which was then bordered by trees, when a shot was fired at him. He started down the road and saw a man in the brush. Sloan grappled with him, and was shot by a companion of the fellow. When Mr. Towne went to the relief of Sloan the three murderers had disappeared. One of them was subsequently caught and placed in the old Courthouse, then in the Hihn building, on the Lower Plaza. He was placed under guard, but next morning was missing. The guards said he had escaped. The Santa Cruzans, who did not place any credit in the story, looked wise, but did not say anything. They did not bother about capturing him; for they were satisfied that he had met his just desserts. The other murderers met violent deaths. One was hung in San Luis Obispo, and the other murdered at Santa Barbara.

Andrew Jack Sloan's ghostly spirit is said to roam between Arana Gulch, where he was murdered, and Evergreen Cemetery, where his remains are laid to rest.

These are but a few colorful characters whose final resting spot lies beneath the earth of Evergreen Cemetery—nearly 170 years of history and haunting tales for future generations to enjoy.

Author's note: Thank you to all of the Santa Cruz MAH volunteers who keep the memories of Evergreen Cemetery alive. If you wish to learn more, the author recommends reading *Ghosts in the Gulch: An Evergreen Cemetery Mystery* by S.L. Hawke.

PHANTOMS OF PARADISE PARK

From the *Santa Cruz Surf* of October 16, 1897:

GHOSTS OF THE SLAIN SAID TO HAUNT THE POWDER MILL

There are strange tales afloat in the little community of Powder Flat, in the canyon of the San Lorenzo, regarding the appearance of spooks of former victims of explosions in the mills.

The workmen of the mills are a sober quiet lot of men, not given to the laughter of merry-making, which is by no means strange when it is considered that they work in the shadow of death. They say when a light-hearted, jovial fellow goes to work there his disposition radically changes in a month or two. He becomes sober, thoughtful, and watchful. His eyes take to themselves an apprehensive expression. A jar, a slight noise, and he springs to his feet all quivering with alarm. He knows that notwithstanding the utmost care and precaution, in spite of the strict rules, a certain number of explosions take place, and that without a moments notices his body may be converted into a number of shapeless fragments of flesh and bone, disturbed around the hills with the inanimate debris of the explosion.

Explosions in the powder mill are invariably mysterious, so much so, in fact, that the failure to account for them by natural causes may imply that there are qualities in powder that are not understood, even by those who are thoroughly familiar with its manufacture. It may be that there are atmospheric conditions which cause these explosions.

Powder Works Mill and track. *Courtesy of Paradise Park historian Barry Brown.*

At any rate the workman has a feeling that he does not understand the giant he handles daily, which is the cause of much of his apprehension.

It may be due to the morbid condition of mind induced by this constant fear that stories of spooks are afloat in the vicinity of the works.

Many of the workmen insist that they see ghosts lingering around the locations of former explosions in which men were killed, and it is impossible to Phoo-Phoo them out of the idea that they actually see them. One of the men, a very levelheaded, practical man, said recently: "There's no use of talking to me about imagination. What I see I see, and there's an end of it."

And the man who sees, or thinks he sees, one of these shocks is frightened, for it is said that they always make their appearance just on the eve of explosions. "They beckon and make signs and cut up all kinda fantastic didoes." *These yarns circulate around Powder Mill Flat and do not serve to lighten the atmosphere any. Lately there is getting to be an idea that the spooks themselves in some way cause the explosion, for the reason that* "misery loves company."

Great difficulty is experienced in getting watchmen to watch at night, especially in spots where an explosion has taken place, as these are said to be the favorite haunts of the bodiless visitors.

Editors note: Visitors to the old California Powder Works grounds often feel the presence of "something"—especially at night.

It was a warm, sunny afternoon on April 26, 1898, and the powder mill employees were winding down their eleven-hour workday routines, as they'd done countless times before. The young men, some a mere sixteen to nineteen years of age, with hands stained black in color, were jovial and cracking jokes among their older peers. The men were eager to get off work. Some looked forward to going home to a cool bath on a warm day, a full meal in their bellies and the comfort of their wives and children. Others were eager to meet at the local saloon for a well-deserved pint of beer and the comforts of a local prostitute.

But this day would be very different from other days. These men would not be going home to their wives and children to eat a hot meal or tuck their little ones in bed. Nor would they be going to the local saloon to drink beer or sow their wild oats. This day would end much differently for the gunpowder millworkers.

At 5:15 p.m. on April 26, 1898, the first of a series of four explosions echoed through the small town of Santa Cruz as the gunpowder mill and its employees succumbed to the worst tragedy in its history. The sonic boom of the explosions shook the ground from the plant of the gunpowder mill all the way to town, breaking windows in its path. Men, women and children looked on from the clock tower of Santa Cruz square, only to scamper for cover as the continuous sonic booms echoed through the valley and littered debris from the skies. Onlookers from town screamed in fright, knowing that the explosions could only mean one thing: death. Just moments earlier, women who were shopping in town with their children or chatting with their neighbors found themselves covering their children's ears from the deafening booms, hiding their little eyes from the sight before them as the sky filled with smoke, flames licked the treetops and splinters of wood, glass and rock shot through the air like high-powered projectiles. The gunpowder mill had exploded.

When the explosions ceased, the stench of gunpowder and clouds of black smoke reached the heavens. Suddenly, the townspeople began to react as the terrible reality set in. Men stopped what they were doing and began running up the mountainside toward the mill to check on their sons, fathers

or friends. Women handed off their children to neighbors to race up the hilltop to search for their husbands, sons or fathers. Chaos filled the hearts of the people of Santa Cruz, as none of them knew if their loved one who worked at the mill was living, dead or injured.

Meanwhile, at the gunpowder mill, the destruction of the explosion was evident everywhere. People lay in shock, some holding their ears, wailing in pain, dazed and disoriented. Many were bloody from head to toe due to shooting debris. A fire began traveling from treetop to treetop, engulfing the small powder mill village where local workers and their families resided. Nearby townspeople and those living at the powder mill village pulled together with buckets and hoses, anything they could find to gather water in from the local San Lorenzo River to put the flames out; they carried the injured to a nearby area that they could use as a triage station.

By morning, the fires had been put out, but the devastation had not ended. As daylight approached, the smoky embers from the debris of lumber continued to smolder. The once tall, green and plush redwood trees that stood proud and strong the night before were now empty smoldering

Powder Works Mill, press house explosion. *Courtesy of Paradise Park historian Barry Brown.*

black sticks. The ground was charred in black soot as ash continued to swirl through the air. The scar of the devastation went as far as the eye could see. The morning light brought the daunting and horrific task of recovering the remains of loved ones whose lives were lost and counting those who were still missing.

Throughout the debris, men searched for the remains of their co-workers. Body parts were strewn throughout the powder mill, and many of the missing were burned beyond recognition. The lucky ones died instantly, and those not-so-lucky suffered agonizing pain before succumbing to their injuries.

A total of thirteen victims died on April 26, 1898, as a result of the gunpowder mill explosion. Two were brothers, and two others' bodies were found completely intact. According to an article in the *San Francisco Call* newspaper dated April 27, 1898, "Only one body was actually recognizable with his head still on its trunk. The rest of the remains could fit in a hat."

A memorial for nine of the victims, who were buried in a mass grave, can be visited at the Santa Cruz Memorial Cemetery. The three remaining victims were buried elsewhere, and one was never found. Below is a list of some of those victims; in all it is believed that at least thirty-five men,

Powder Works Mill, wheel mill explosion. *Courtesy of Paradise Park historian Barry Brown.*

maybe more, died as a result of explosions while employed at the powder mill. According to the research of historian Barry Brown, the California Powder Works Mill, which made commercial-grade gunpowder from 1864 until 1914, endured at least fifty explosions while in operation.

- Guy Seward Fagen, sixteen years old
- Charles Miller, sixteen years old
- Luther W. Marshall, eighteen years old
- Ernest Marshall, nineteen years old
- Benjamin E. Joseph, nineteen years old
- Ernest Jennings, twenty-one years old
- James E. Miller, twenty-seven years old
- Henry C. Butler, forty-five years old
- Charles A. Cole, fifty-one years old

On July 6, 1898, the *San Francisco Call* posted this rather satirical interview:

Captain Rottanzi's Woes
Thrilling Description of Hardships at the Powder Mills

Captain-Doctor Supervisor Rottanzi, handsome and debonair, marched into the office of the Board of Supervisors yesterday afternoon, garbed in the natty fatigue suit of a captain of the army, brown as a San Joaquin farmer and delighted to be absent from his dangerous post.

"I tell you my friends" said he, "it is a great relief to get away from that confounded Santa Cruz powder mill. Why, I am just beginning to take long breaths again. It is a fact that I don't dare sneeze down there without putting my head in a blanket."

"If the military authorities want to keep Captain 'Billy' Barnes from outgrowing himself, they should send him to my post for about six weeks. He would, if he survived the mental strain, come back a mere phantom and could have his clothes made over and get two suits out of one.

"Talk about mental anguish. Why, my tent is only forty paces from a silent horror in the shape of fifteen tons of powder; a short distance away is another sleeping volcano, and up the hill a little further is a nightmare that haunts my sleeping and waking hours worse than a guilty conscience. It is only a little matter of 200,000 pounds of concentrated death. Woo! It is horrible to think what would happen to me if that stuff should conclude to expand without giving due notice.

Powder Works Mill workers, Paradise Park. *Courtesy of Barry Brown.*

"The Coroner might find only an assorted lot of fingers as a result, and my friends might mourn over and bury the digits of Corporal Casey or Mr. Shultze, thinking it was my beloved remains." The other day I got some left-hand encouragement from an old employee at the works.

"How long have you been here? I asked. "Twenty-one years" he replied. "So long and not killed yet?" "Sure, there no danger. Of course we had a little explosion a few weeks ago. It was only six tons of powder, blew the whole place clean as paper, though, there were 3 hearses over there a short ways and it was very funny, sure. The powder blowed them inside out and we never found a hair of them left."

"How did you escape?" "Oh! that was easy, I hid in the water trough and only got wet. Now be easy, captain; ate and slept well, for I've been here, as I told you, twenty-one years and never was killed. There's no danger."

"You say six tons blew the whole place clean as paper and there is no danger with fifteen tons of powder under my nose and a train-load a few rods away?"

"To be sure sir; because that explosion was just an accident!"

The Powder Works Mill is currently known as Paradise Park, a Masonic living commune comprising multiple dwellings privately owned by those who are direct descendants of Masonic affiliates. Although the park residents relish their privacy, private tours with local historian Barry Brown are permissible. Residents (who wish to remain anonymous) have, in fact, described seeing ghostly glowing apparitions of individuals dressed in former railway attire, perhaps loading up kegs of gunpowder for transport. Others have mentioned a Lady in White, wandering around the center grounds of Paradise Park, and still more have seen the same described Lady in White wandering along the San Lorenzo River beyond the gates of Paradise Park. She is seen late at night on the lowly roadway heading toward the cemetery nearby known as Santa Cruz Memorial, off Ocean Street Extension.

LADY IN WHITE

Santa Cruz lore that predates the 1960s has described sightings of the Lady in White by wayward teens who frequented an abandoned house near the cemetery, a teen hangout away from prying parental eyes. Stories yield a fantastical tale derived from the 1870s of a young mail-order bride from Massachusetts. Her arranged marriage was to a local drunkard, who allegedly forced her to traipse about the house each night in her wedding dress while he blatantly beat and demoralized her for nothing more than his own depraved amusement.

Local lore claims that the young bride sought to escape her abusive husband; however, he grew wise of her disobedience and beat her to death before burning the body in an attempt to hide his evil deed. For generations to come, the bizarre tale has contended that the disembodied spirit of a woman in white wanders the road of the Ocean Street Extension toward the cemetery seeking vengeance in her wake.

So, is this nothing more than a tall tale spread by carousing teenagers for a night of thrills and chills? Perhaps, but what of those credible witnesses who reside at Paradise Park? They, too, have claimed to see the apparition of a ghostly woman in white who wanders from the Old Powder Works Mill of the park and down the road along the San Lorenzo River toward the cemetery.

The mythology of the white lady is spread in different cultures worldwide. The common belief is that the wandering woman in white is a young female

whose life was cut short at an early age. She often searches for a lost loved one or seeks revenge against a male counterpart who betrayed her heart. Whatever the case may be, the legend of the white lady is one that is globally recognized and told in numerous regions.

So, what of the Santa Cruz white lady? Although there is no historical evidence of a young mail-order bride who was betrayed by her husband, beaten and then burned, there is, in fact, a reference to a prominent young socialite by the name of Myrtle Rountree, who was badly burned and whose life was later cut short, thwarting a future with the love her life.

Her history traces back to 1913, to when the Powder Works Mill (Paradise Park) was still operational and harboring its deadly black powder. Thomas Rountree, an employee of the gunpowder refinery and father to young Ms. Myrtle, brought his wife, children and family friends the Scotts to the Powder Works Mill Village, beside the adjoining riverbed of the San Lorenzo, for an afternoon picnic like he had done many times before.

What started as a carefree day of fun in the hot August sun, with children playing and men and women engaged in jovial conversation, quickly turned into a nightmare that would scar them forever. While eating lunch on the bank, thirteen-year-old Alonzo Scott ignited a match and threw it into a pile of what was initially thought to be asbestos; however, the debris-filled pile was actually filled with gun cotton, a highly flammable nitro. The flare-up that followed engulfed the picnickers in flames, causing severe burns, but no one's burns were as severe as young Ms. Myrtle Rountree, who was fifteen years old. She suffered severe burns around her face and back, and her clothes nearly completely burned away from her body.

Fortunately, the families recovered from the tragic event, and four years later, in the winter months of 1917, Ms. Myrtle Rountree, age nineteen, married the first love of her life: her childhood sweetheart, Everett Whitesell. What should have been the harmonious nuptials of a young couple with a long future ahead of them and the dream of starting a family of their own turned into a story of gut-wrenching heartbreak. Only a mere two months after their marital bliss, Mrs. Myrtle Whitesell took gravely ill and tragically died of tuberculosis. Young Everett was beside himself with grief—the love of his life was suddenly lost.

Although old newspaper articles reference a small funeral that was held for young Myrtle, there are no records to date that show where she was laid to rest. While both her parents' bodily remains rest at a local Felton Cemetery, and many of the Rountree descendants lie in the cemetery at the end of Ocean Street Extension from Paradise Park, young Myrtle's

remains have yet to be discovered. This has led to the belief that it is her ghost that aimlessly wanders down the road in the wee hours of the night. Perhaps she wanders to and from some of her favorite spots or places of otherwise tragic memories with her family near the mill. Maybe she wanders to find her childhood love, the husband whom she adored so dearly and lost so suddenly, or perhaps she wanders to the cemetery, trying to find her place among the headstones—a place with her family, a place where she has no name.

THE CURSE OF RISPIN MANSION

Many Santa Cruzians are familiar with the legend of the Rispin Mansion, derived from tales of a dreaded curse that prevents anyone from successfully owning the historic manor to rumors of the dead that still haunt its halls. The ninety-two-year-old mansion, which stands four stories tall and houses twenty-two bedrooms, has remained vacant for nearly sixty years, over half of its existence.

The legendary curse begins with Henry Allen Rispin himself, a well-off San Franciscan who acquired the mansion with the intention to turn it into a resort called Capitola by the Sea, only to endure a series of misfortunes that resulted in the death of his only son, the divorce of his wife and the final blow of complete financial ruin.

After losing everything, he wandered the city streets a vagabond, homeless and penniless. Even after he died, Henry endured the ultimate indignity when neither a relative nor a friend nor even an empathetic former wife would claim his remains. Instead, Henry Rispin was left to decay in a pauper's grave with not even as much as a marker to read, "Here lies Henry A. Rispin—Poor Bastard." Henry's calamity left him to decompose among Alcatraz's finest serial murders and Death Row inmates in the unmarked fields of the Olivet Cemetery in Colma, California.

After Henry's string of misfortunes at the Rispin Mansion, another man tried his luck with the estate. Lured by the majestic manor, millionaire Robert Smith Hays purchased the estate at a banker's foreclosure price, and along with the mansion, he acquired all of its lavish furnishings. However, before

Right: Henry Allen Rispin. *Courtesy of Capitola Museum.*

Below: Rispin Mansion, circa 1920s. *Courtesy of the Santa Cruz Museum of Art and History.*

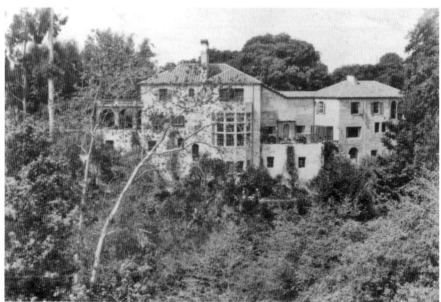

Hays could enjoy the home's grandeur and lavish furnishings, his lovely wife soured at its grand décor—if for no other reason than she hadn't come up with its copious interior design and could not take credit and so indulge her ego among her high-society friends.

Perhaps Hays should have taken his wife's disapproval as a sign of bad fortune to come. Not long after Hays acquired the mansion, he, too, felt the Rispin curse when he lost his vast millions during the stock market crash and was forced to surrender the mansion in an undignified manner for someone so affluent.

Between 1939 and 1941, the monstrosity of a manor remained vacant until the Catholic Church acquired it, turning it into a convent for the Sisters of the Poor Clares. Its walls echoed with harmonious songs to the heavens and God above. The sisters rejoiced in praise for their newly acquired haven. Surely the good sisters, with their meager possessions, their hearts filled with love and free from greed, devoted to the Lord, had lifted the mansion of its dark, foreboding curse. Or perhaps with no greed-

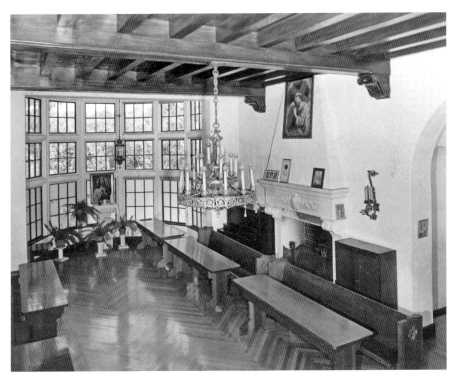

Inside the Rispin Mansion's main living hall while owned by the sisters. *Courtesy of Santa Cruz Museum of Art and History.*

filled souls to feed from, something else awoke within the depths of the mansion's cavernous walls.

It is common knowledge that the sisters remained at the convent for a little over a decade. During this time, they endured being made a spectacle of by curious passersby, who often peeked through the vast mansion windows. It was also common knowledge that the sisters were required to don traditional attire consisting of a habit, veil and open-toed sandals. The cold cement floors, open-toed shoes and poor heating were said to have been intolerable for the sisters who occupied the mansion. This is the reason given for why the poor sisters eventually left the mansion. But was this the real reason?

Local legend has claimed that this menacing manor is haunted by the apparitions of an old man with glasses who sits in a rocking chair reading a book before he suddenly vanishes. Others have heard the ferocious bark of what they believe is the spirit of a demonic dog that wards off all who attempt to enter. But the most common claim is that of a woman in black who stares out from the upper balcony that overlooks the creek, observing anyone who dares to come near the estate. Could this apparition be that of a nun who continues to wander the halls of the Rispin Mansion, protecting the sacred monastery where she once dwelled?

Sarah M. Harvey, a paranormal researcher and respected spiritual sensitive, shared her exclusive private diary from her 1999 investigation, accompanied by a few of her associates. She goes into detail of her experiences while researching the Rispin Mansion. Here is an excerpt from her diary:

April 1999

The door to the mansion was open. Adie and I stood in the dusty stale air feeling icy cold fingers crawling on our backs. Whispers began to creep into my head. A woman's voice, low, soft and melodious dominated. "Julia? Nicole?" I mentally told it no, we were not Julia or Nicole, but I asked what her name was. Her answer was something like Rosella, Rosaria or Rosanna. We decided on Rosella, which is what we still refer to her as.

A shadowy form materialized opposite the fireplace. An average looking woman, dark hair, wearing a plain dress that looked grey and had some kind of large collar that went from her high neckline and fell in a large square over her shoulders and across the front of her dress. I couldn't tell if it was the light or the fall was lace. She had a pale complexion and straight dark hair.

She seemed very friendly and expressed loneliness, frustration over the state of the house, and the desire for an old leather bound gilt-edged bible.

She said she liked us and wanted us to return often to speak with her. She wanted us to stay longer that day. But the chill became overwhelming and it did not emanate from her. Adie and I backed out of the house.

I returned home and laid down for a nap. And I had a terrifying vision. Adie and I had returned to the Rispin Mansion with an old friend Julia and flashlights.

We entered the front door and were only a few steps down the main hallway that runs along the front wall, when this hairy, beastly, thing came tearing down the hall at us. It was like a mix of a rabid dog and a giant rat. We screamed. We heard Rosella screaming and telling us to run. We ran but the thing was faster than we were. The thing clawed at us. It left no physical scars, but it felt like it tore out chunks of our souls. I woke up screaming and covered in a cold sweat. It took almost an hour to stop shaking and for my heart rate to return to normal. Needless to say we didn't return to investigate the mansion that night. I have returned on several occasions, usually with my friend Julia. We have never found the door open again however.

But just being on the grounds, especially on that back patio a tingling, light headed sensation permeates body and mind. Steps are hard to negotiate and the world is a hazy slow motion.

On one of our subsequent visits to the mansion with Julia, we found one of the windows near to the ground on the front of the house was open. We could sense Rosella, but she gave us the impression she could not leave to Portico Room.

There was an impression that Julia and her daughter (she's 3) had of a man with glasses near the fireplace. He seems to be trying to get a piece of paper with a phone number on it—supposedly in or around the fireplace. But he is upset because he has finally found the number but the phone is down stairs and he can't get to it.

We also had a frightening sensation of being watched by something angry and stalking back and forth just out of view. It came close and Julia's daughter screamed and began to cry about "the bad doggie!"—her other comments included "he's bad," "he's mean, he'll hurt me!"

We left soon after. The little girl was very scared. I have also had impression of a dead body in one of the basement rooms, a recent death one from drug parties in the 1960s or '70s. It occurred to me as I walked around the building below the steps up to the brick back patio.

We also noticed under the first set of stairs as you descend towards the walk to the back patio. It is one solid piece of poured concrete. To the left

of it is an out building. It has 4 walls, but no roof. A tiled floor and a sink. It was then that Julia and I were returning from investigating the garden building when we noticed a tiny, one foot square window under the stairs—along the side. The window is steadily barred. It is impossible to see beyond a few pipes and walls. It is all concrete, perhaps a boiler room? A cold moving draft cuts through that room. It radiates cold, dark, dank evil. And is evidently sealed off from the rest of the house.

Julia and I noticed the "notices" posted about, regarding the renovations, dating this April 1999, I immediately started to research the company to get in touch with them and offer my services to deal with the spirits in the house. I was very afraid for the safety of anyone working on the house. The black dog does not want outsiders in the house. I think it would hurt people. The other ghosts want the house to be beautiful and well again. I think they will be alright once things are explained to them.

While continuing to uncover the Rispin Mansion's haunted past, Sarah M. Harvey was able to visit with the Sisters of the Poor Clares and conduct an interview with a few who once dwelled at the Rispin Mansion while it was a monastery. Here is a written portion from those interviews:

May 4, 1999
Last week, Elizabis and I interviewed the Mother Superior of the Poor Clare's order. They inhabited the Rispin Mansion from 1940–1956. Mother Clare was a sister there for most of this time. She was able to extensively describe the buildings, outbuildings, and environs. She did not report any apparitions or strange encounters during her stay. She joked that if there had been, they would have left the house sooner. But, when I first broached the subject, Mother Clare was noticeably shaken and a little nervous about the subject. I prodded a little more, but she seemed to be getting upset so I let the matter lie. She did not seem to know of a sister Rosella. But nuns tend to change their names when entering the convent, but who knows.

We requested photos from the Poor Clare's.

May 5, 1999
Elizabis went to pick up the photos from the Poor Clare' today. She chatted with one of the sisters and that sister said that "Of course the place was haunted!" Elizabis's answering machine message also said something about the secret room or rooms. Waiting to hear from her in person.

…Exciting News! I just got off the phone with Elizabis and she gave me the rundown on what happened at the Poor Clare's this evening. According to the sister she talked to the house was indeed haunted. The sister figured something awful must have happened in the house because it was still fairly new. But she said the ghost's never bothered them really, just made noise.

…There was knocking on the walls and footsteps throughout the house. There would be knocks at the door but no one would be there. There were two windows, under the portico on the ground floor under the ballroom that they would find open late at night. The windows opened from the inside, but none of the sisters could figure out how to get into that room. The way the sister put it, they couldn't find the room. Later in the day the windows would close themselves only to be opened again that night.

…There are also several secret rooms and closets, probably from the Prohibition days when the house was originally built. In the library there is a closet. In the back of the closet there is a place to put a screwdriver and the back wall opens out to reveal another closet.

…In one of the bathrooms there is a compartment under the sink. In the master bedroom which is the balcony room above the ballroom, there is a false wall which opens up to reveal a whole other room.

…Tomorrow morning, I am going to call the convent and see if I can talk to the sister that 'Lis talked to. Maybe I can talk with her a little longer and get some more stories from her.

May 6, 1999

Talked to Sister Antoinette today. She insisted on the haunting. Her ghost experiences were as follows:

An eerie chilling feeling in the library, she thought there had possibly been a murder there.—In the upstairs bathroom she heard knocks on the door after a shower, but no one was around. Another sister also reported this happening a few times as well.

While she was in the chapel, her rounds were 4–5 A.M., she would hear footsteps up and down the steps outside but would find no one out there.

She also told of hidden doors. Behind the library shelf, in the master bath, a hallway with a false end.

Sister Antoinette was very excited to talk about it. And she wants to come with us on the walk through! She's very excited about the whole process.

Also, I spent almost 2 hours in the library trying to search the Rispin Mansion on the net. There were a hundred or so sites, but they all came up "404 File Not Found." Very frustrating!

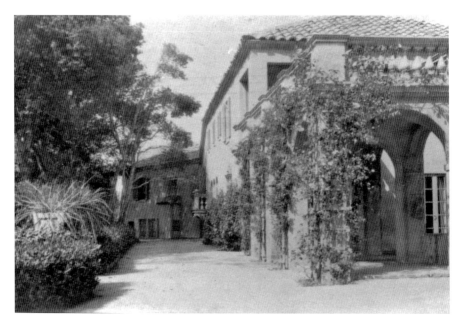

The Rispin Mansion vigilantly awaits its next victim. *Courtesy of Santa Cruz Museum of Art and History.*

As a nun, Sister Antoinette would have sworn an oath to speak only the truth. It seems unlikely that she would have lied about the paranormal activity she experienced in the mansion. So perhaps something unexplainable haunts the mansion after all?

The nuns ultimately vacated the Rispin property around 1956, after adding many additional outbuildings and a chapel. The Catholic Church abandoned the property and relocated the sisters to a new monastery closer to the ocean and away from the prying eyes of the local townspeople. So did the sisters move out because they got cold feet? Wouldn't it have been more cost-effective to just purchase closed-toed shoes? Or was there another, more sinister reason for why they fled the property?

In May 2009, new developers fell victim to the Rispin curse. After signing a $14 million contract with the City of Capitola to renovate the Rispin Mansion, the mansion mysteriously caught fire, and 75 percent of the building was gutted. In 2011, the City of Capitola voted four to one to cut short any further renovation projects with the Rispin Mansion developers and unanimously agreed to entomb the once majestic manor.

To date, the mansion remains owned by the city and stands vacant and securely boarded up, harboring nothing more than its lonely ghosts

that dwell within—thwarting off any of those who dare to enter its dark catacombs or who desire to unveil its lurid secrets. Perhaps someone will come along and try to purchase the Rispin property again one day. In any case, there's no doubt that if the curse of the Rispin Mansion does exist, it is vigilantly waiting for its next victim.

Tuttle Mansion Madness

Built in 1899, the haunted Tuttle Mansion was originally designed by famous architect William Weeks, an iconic and historic builder of the 1800s. The three-story mansion known as the "crown jewel of Watsonville" was designed for well-to-do rancher and Masonic member Morris B. Tuttle. Located near the town of Freedom in South County Santa Cruz, the grand California Queen Anne–style structure has withstood the test of time, enduring the San Francisco earthquake of 1906 and the Loma Prieta earthquake of 1989. The latter nearly knocked this majestic behemoth to its foundation. After the quake, it took the family of the current owners, Kathy and Jeniffer Oliver, nearly two years to restore.

The Olivers' love for this fabulous piece of Santa Cruz history does not go unnoticed. The full restoration of this magnificent self-standing piece of art speaks for itself. Rising three stories tall, the house is inlaid with Hungarian ash oak and cedar, along with imported Birdseye maple and mahogany and contains well over a dozen rooms. Morris Tuttle spared no expense in the creation of this extravagant, alluring mansion. One can only imagine the grandiose parties and lavish lifestyle the original Tuttle family enjoyed during their occupancy. In their heyday, the family was well respected, affluent and powerful. Many members of the Tuttle family were involved with and held posts in highly esteemed local organizations and guilds, such as the Masons, Knights of the Templar, IOOF, Shriners and the Santa Cruz Lodge of Elks. However, despite their successes, dark, vilifying stories surrounded the Tuttle family. Like

most families, they had their skeletons, and it could be that some of these skeletons still roam the manor today.

Jeniffer and her twin sister Kathy Oliver are long-standing business owners of Oliver Realty and Dusty Treasures & Antiques. They explained that the mansion, which currently houses various rented-out business suites, is not without its unusual quirks. The Olivers claimed, "When the halls close after business hours and all appears to be quiet, the mansion seems to take on a life of its own." There have been reports of the endless sound of tapping from an old-fashioned typewriter, seemingly typing all by itself, the repeated sound of doors slamming open and shut upstairs while its halls above lie vacant, sightings of the apparition of an elderly woman ringing a dinner bell who seems to vanish and the echoing spirits of children at play who wander its vestibule late at night.

Local paranormal research team the Santa Cruz Ghost Hunters even had its fair share of personal haunting experiences at the grand Tuttle Mansion, with eyewitness accounts of childlike apparitions floating through its halls, multiple electronic devices simultaneously turning on, electric voice phenomena being caught on audio, odd orbital spheres caught in photographic images and the occasional unsuspecting tug on a piece of clothing arousing an arm full of chilling goose bumps. The extraordinary

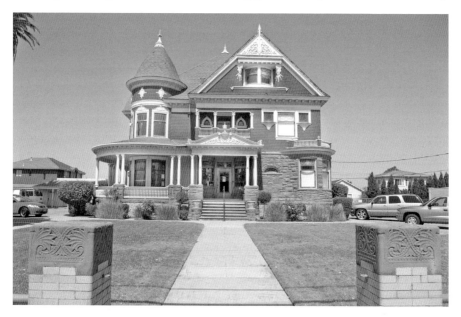

The Tuttle Mansion, built in 1899, is believed to house the spirits of the many Tuttle family descendants.

experiences felt at the Tuttle Mansion are very real—as real as the Tuttle family's lengthy history wracked by murder and suicide.

History tells us that the Tuttle household was a large, multigenerational family, having as many as six to twelve children per marriage. There is evidence the Tuttle descendants displayed traits of great wealth, education, power and drive, but there is also evidence that the family was characterized by homicide, incest and evil genius. The Tuttle family traces its origins back to the late fifteenth century, with roots in Ireland and England, having originally migrated to the United States by way of Massachusetts as early as 1635.

One tale of Tuttle madness dates back to 1676 in New Haven, Connecticut, when young Sarah Tuttle, daughter of William Tuttle, had brought shame on her family for allowing a boy to kiss her without parental consent. This behavior was unbecoming of a virgin with Puritan values, and it was sinful not only in the eyes of the law but also before God himself. Apparently, Sarah's twenty-nine-year-old brother Benjamin also found the deplorable act unbecoming of his young sister, and the two siblings became engaged in a heated quarrel. History is uncertain as to the exact nature of the quarrel; however, it seems big brother Benjamin felt that the fight warranted his young sister's demise. He acquired an axe from the family barn and bludgeoned her over the head multiple times until she lay dead. In 1676, brother Benjamin was convicted of his sister's murder and sentenced to death. I suppose it would be fitting to say that brother Benjamin killed two birds with one stone, as he brought about his own death.

One year later, the eighth daughter of William Tuttle, by the name of Elizabeth, who was wed to Richard Edmunds, an affluent gentleman with strong moral values, was demonstrating insanely psychotic behavior. Her breaking point likely occurred after her sister Mercy killed Elizabeth's son the previous spring for unknown cause, as well as the deaths of both Benjamin and Sarah. As impending madness tormented Elizabeth's mind, she began to distance herself from her husband, deserting his bed and her wifely duties, threatening to kill him while he slept and even going as far as to admitting that she was not pure when they wed—in fact, she admitted to giving birth prior to meeting Richard, and her father, William, was raising the illegitimate child.

Having no more desire to be in the loveless marriage, poor Richard filed for divorce with the magistrate on July 2, 1689. At first, his petition was denied, but he petitioned again and based his divorce action on the following four reasons: "(1) Her being guilty at first of a fact of ye same nature; (2)

Her refusing me so longer together; (3) Her carriage having been observed by some to be very fond and unseemly to some other man than my self; (4) Her often commending on other man with show or ye like words…he was worth a thousand of my self." Richard also contended that he feared his wife because she often threatened him. The magistrate finally granted Richard a divorce and the freedom to resume his life and remarry.

There is no record of Elizabeth ever remarrying. Coincidentally, there is no record of the date of her death, either, which leads us to believe that she may have been leading a marginal existence by the time she died. It is possible, too, that she committed suicide. Suicide was a grave sin in those times, and a person who committed suicide could not be buried in a cemetery on hallowed ground. It is possible that she had wandered to another wilder part of the country and died in an area where records were not kept.

Throughout the decades, the Tuttle lineage spread far and wide throughout the United States, and many of the family's descendants settled in California and the county of Santa Cruz. Morris B. Tuttle came from Iowa and acquired 300 acres in a farming town called Watsonville, in the south county of Santa Cruz. Of those 300 acres, Morris Tuttle utilized 160 of them to become a successful fruit tree farmer and orchardist along with one of his many brothers, including Iowa Tuttle, who was named after his home state.

In 1913, Morris's brother Iowa H. Tuttle, age forty-four, husband and father of three, shot and killed himself in an outbuilding at the Tuttle Mansion. According to Morris B. Tuttle, his brother had threatened suicide on more than one occasion due to financial woes; his body was found to have been shot twice in the head. Two chambers were found empty in the revolver when it was picked up near the body, and a loaded cartridge still remained in the gun.

Brother Morris B. Tuttle was questioned in detail at the coroner's office, as they tried to rationalize how it was possible that Iowa fatally shot himself in the head twice. Iowa was known to be a loving father and devoted husband, despite alleged financial woes, and it was common knowledge that Morris and Iowa didn't always see eye to eye. Although the circumstances were thought to be suspicious, the inquiry was thought to be satisfactory, and the coroner ruled the death a suicide.

However, this was only one of many similarly tragic deaths suffered by the Tuttle family throughout their Watsonville history. In 1888, Flora B. Tuttle, daughter of William Tuttle, passed away at the age of twenty-two. Hazel Tuttle passed away at the young age of twenty-eight; Kilburn Tuttle was age

thirteen when he passed away in 1918; Margaret Emma Tuttle, daughter of Daniel Tuttle, died at the age of nine; Johnnie Tuttle, son of Owen Tuttle, passed away at the age of two years, eleven months; and Irma Tuttle, daughter of F.G. Tuttle, passed away at the age of seven after accidently falling on a roller driven by her cousin Allen Tuttle, according to the June 8, 1902 *Santa Cruz Sentinel*:

> SKULL CRUSHED
> *Irma Tuttle Falls from a Heavy Ring Roller and Receives Injuries from Which She Can Not Recover*
>
> *Irma Tuttle, the eight year old daughter of Mr. and Mrs. Frank G. Tuttle is the victim of a most distressing accident. The little one was riding on a heavy ring roller which was at work in her father's orchard southwest of town when she fell from her seat, and before the driver could stop his horses the roller, which weighs about 1800 pounds, passed over the child's head. The horror of the situation can better be imagined than described.*
>
> *The little one was lifted up tenderly and conveyed to her home. An examination revealed the fact that the child skull was crushed. The surgeons extracted two pieces of bone, each of which was about an inch long and did all in their power to alleviate the pain, but could hold out no hope for the little patient's recovery. Her injuries were of such a serious nature that her death is only a matter of a few hours.*

But alas, Tuttle madness continued to rear its ugly historical head with the marriage of pureblood descendants William Tuttle and first cousin Hazel Tuttle. What started out as marital bliss quickly spiraled toward divorce. The cousins, who grew up together, thought they were madly in love. Soon after the marriage, though, the pair grew weary of each other and would viciously argue. Despite having a beautiful nine-month-old blond-haired, blue-eyed daughter named Alice, the marriage was no longer salvageable. It would not be long before William would finally succumb to his madness.

For twenty-five-year-old William Tuttle, his whole world seemed to come crashing down on him. He had been unemployed for months after losing his job as a fireman with the Southern Pacific Railroad. William was on the brink of losing everything—his marriage, his daughter and his home. Finally, fueled with despair, on December 30, 1911, he walked into his home, entered his wife Hazel's bedroom and administered a deadly shot at point-blank range into his wife's chest before turning the revolver on himself.

Police found both lying side by side on the floor dead; nine-month-old baby Alice laid laughing and playing in the dining area nearby, oblivious to the knowledge that both her parents were dead.

According to the family housekeeper, the couple had been estranged for the last several months, and divorce was imminent. William Tuttle was strained by financial hardship and had begun to mentally unravel. William had come home while his wife was in town running errands. He came bearing gifts for young baby Alice—belated Christmas presents consisting of a teddy bear, a toy cat, a doll and a bright-red rubber ball. According to the housekeeper, he played with baby Alice before his wife came home, with no indication of the calculated madness he intended to exact.

As the bodies were laid on gurneys to transport to the coroner's office, young baby Alice was held in the arms of the housekeeper. Little Alice stretched her little arms outward toward her deceased mother's remains, taking one last look at her mommy's pale still face; she cried, yearning for her as the coroner toted the body away—a heart-wrenching moment for all who bore witness to the already horrific scene that lay before them.

However, little baby Alice's plight did not end here, as family members from both Hazel and William's side argued for custody of her, as well as the substantial dowry the little girl stood to inherit. With both parties bickering for three days straight, presiding judge McLaughlin of the Sacramento courts independently decided that neither party would retain custody of Alice, for her own well-being. The judge, who was a friend to the child's deceased mother, Hazel, took it upon himself to find Alice a new family to look after her instead.

Neither party argued with the judge, and little Alice was ultimately adopted by a loving couple who changed her name to Shirley Weisman. At the age of twenty-one, Shirley received all of her inheritance in property, stocks, bonds, cash and jewelry—well over $75,000, a large fortune in those days. She later married Howard Benedix; however, once again an ironic incident of Tuttle madness seemed to cloud the skies on January 5, 1938.

According to Shirley's husband, Howard, while out testing some new guns in a remote Sacramento area, with Howard at the wheel and Shirley on the back of the buckboard, a terrible accident ensued. Shirley allegedly yelled for her husband to "Stop the car!—I see something to shoot!" and aimed her double-barreled long-rifle shotgun at something in the distance when, according to Howard, the family dog came running up from behind the car and jumped up on Shirley, causing her to inadvertently shoot herself in the head with one of the single shotgun shells, killing her instantly. She was

twenty-six years of age. Ironically, the suspicious death was taken at face value and ruled an accident; her husband is presumed to have inherited her fortune. Shirley bore no children, leaving nothing more than a legacy of both mother and daughter losing their lives by gunfire.

The Tuttle Mansion is believed to be a portal, harnessing the energy of family descendants, both immediate and distant alike. It is a doorway for those spirits that may be trapped in this world or even those that simply choose to stay. The mansion seems to draw those in, those that have crossed paths even in history. Such is the case with the current owners, the Olivers, who have owned the vast mansion for the last forty-two years and, unknowingly, have had their own family name cross paths with a Tuttle in an ironic, twisted tale of Tuttle madness. In a news article from the October 21, 1890 *Sacramento Daily Union*, an eerie coincidence of murder, suicide and namesake takes place nine years before the birth of the Tuttle Mansion itself:

> *HOMICIDE AND SUICIDE*
> *The Pistol Very Effectively Used in Several Instances*
>
> *CHARITON (Iowa) October 20th.—Saturday afternoon Elener Oliver, aged 21, arrived here from Kansas. He hired a livery team and drove to the little town of Freedom. He then went to the house of Mr. Tuttle and requested to see his daughter with whom he was in love. He requested the girl to marry him and she refused, saying she was too young. Oliver, at this reply, pulled out a revolver and shot the girl through the temples, causing instant death. He then turned the weapon upon himself and fired a ball through his head in the same place he had shot the girl. He lived in an unconscious condition until this morning, when he died.*

Despite the strange Tuttle family history of murder and mayhem, it seems only befitting that this piece of haunted history is loved by Olivers.

LEGENDS OF MOUNT MADONNA

Mount Madonna, located off Hecker Pass Road on Highway 152, is situated between two mountain peaks separating the Santa Cruz County line and that of Santa Clara; it is home to both an abandoned inn and a legendary haunted campground.

The Mount Madonna Inn was once a former hot spot for dining, dancing and drinking, and its grand structure spreads out over an amazing fourteen thousand square feet. This mountaineer manor shares urban panoramic views from its vast picture windows as far as the eye can see. With its early 1970s motif, this portal to the past has remained eerily docile, its doors heavily chained and locked for more than a decade, hiding a chilling history that is grounded in the very earth where the structure stands.

Around the bend from the inn stands the entrance to the famed Mount Madonna County Park. This campground caters to thousands of happy vacationers each year, many oblivious to the ghostly tales and historic legends on which they literally pay to camp.

The hills of Mount Madonna, once a flourishing hunting ground with clean, clear waters and an abundance of wildlife, has a lengthy history dating back to the Ohlone Indians who once called the area home. These hills were resident to hundreds, if not thousands, of thriving Native American families and tribes for more than three thousand years.

The Spaniards, who arrived in the eighteenth century, ultimately converted the native inhabitants to their Spanish Catholic beliefs, changing the identity of their proud culture forever. This once thriving and healthy native nation became

all but extinct, thousands of natives became enslaved and abused, succumbing to sickness to which their bodies had no immunity. For those who were fortunate enough to survive, the end was yet again bittersweet, as many tribal women were left no longer able to bear children, making repopulation futile. Within a few years, the Ohlone tribes on Mount Madonna were all but extinct, as hundreds of the tribe's people perished, their bodies buried or burned on the hills of Mount Madonna.

To this day, the remaining Ohlone descendants gather in the nearby Mount Madonna County Park each summer solstice to celebrate the memory of their Ohlone ancestors and pay homage to their spirits that once lived on these sacred lands.

However, Mount Madonna's revered past is only one part of its haunted legend. Moving forward to 1850, a European immigrant by the name of Henry Miller, best known as the "Cattle King" and the founding father of the Los Banos area, made his way to California during an era when the gold rush was taking over the West. Henry Miller had monopolized the cattle industry and began his land purchases in the Gilroy area in 1863, earning him his nickname. Miller ultimately acquired more than 1.5 million acres between California, Oregon and the Nevadas. He ranched more than 1 million head

Top: Henry Miller estate, Mount Madonna, 1900s. *Courtesy of Gilroy Museum.*

Bottom: Henry Miller, the "Cattle King." *Courtesy of the Gilroy Museum.*

of cattle and 100,000 sheep. At the time of his death, Miller had a net worth of more than $40 million, which is an astronomical fortune, even today. Miller's two most famed properties were the Bloomfield Farm in Gilroy and his summer estate on the Santa Cruz mountains of Mount Madonna.

Although Miller was incredibly successful with his wealth and fame, he was not as fortunate with his loved ones. Henry Miller married Nancy Sheldon in 1858 while living in San Francisco. According to the Gilroy Historical Museum, Nancy died in 1859, immediately after giving birth to their first son, Henry Jr.; subsequently, the child also died soon after birth. He later married Nancy Sheldon Miller's sister, Sarah Elizabeth Sheldon, also in San Francisco in 1860. Sarah was able to bear four children. Mysteriously, though, only two of those children actually lived long enough to reach adulthood, and only one was able to bear them grandchildren (and an heir to the Miller legacy).

As in most families, there was a favorite child. For Henry Miller, it was his youngest child, Sarah Alice Miller, fondly referred to as "Gussie." Sarah was born on December 21, 1871, and died on Friday, June 13, 1879, at the young age of eight. Young Sarah was riding her horse at the top of a Mount Madonna trail with family while heading back to town. Her horse lost its footing, fell and landed on young Sarah, crushing her skull with its massive weight, as noted in this June 14, 1879 article provided by Gilroy Historical Society:

HENRY MILLER'S CHILD INSTANTLY KILLED

A deplorable accident, resulting in the instantaneous death of Sarah Alice Miller, daughter of Henry Miller, occurred yesterday on the road about a mile north of the Bloomfield ranch. The unfortunate and estimable girl was an excellent and fearless rider, although scarcely eight years old, and the horse upon which she was mounted is one of the most gentle of beasts, and one which she had frequently rode. It appears that a part of the family were on their way to town, some in a buggy and others on horseback. They were travelling along at a leisurely pace when the horse stumbled and the poor girl was thrown to the ground. It appears in the effort of the animal to recover its footing, it slipped and fell upon the head of the prostrate child, crushing her skull and forcing out a flood of blood from her ears and mouth. She was picked up dead and conveyed by the grief-stricken company to the ranch. The whole communities sympathize with the afflicted family.

Sarah Alice Miller, age eight,
died in a tragic horse accident.
Courtesy of the Gilroy Museum.

While the ruins of the Miller estate still exist to this day on site of the Mount Madonna campgrounds, many who are familiar with the story of young Gussie's tragic accident claim that her spirit still wanders the mountainous terrain where she loved to frolic. According to the Gilroy Historical Society, little Sarah's body was buried at a family plot at their Bloomfield farm in Gilroy. Although it was believed that the child's remains were housed under a cement slab resembling a grave marker on the former Mount Madonna estate, a final will and testament of Henry Miller notes that it was *he* who wished to be buried upon his death on Mount Madonna.

Although we may never know for certain if Henry Miller was ever buried on Mount Madonna, history records do confirm that after the death of Henry Miller in 1916, little Sarah's remains were exhumed from the Bloomfield Ranch and reburied at the Woodlawn Cemetery at the Miller family plot located in Colma, California.

Throughout the decades, the legend of young Sarah Miller's tragic death has been retold from generation to generation, with changes in variations and validity, mixing fact and folklore. According to former

The Bloomfield Farm, once owned by Henry Miller in Gilroy. *Courtesy of the Gilroy Museum.*

Mount Madonna Inn owner Gene Beadnell and the book *Santa Cruz County Place Names* by Donald Thomas Clark, Mount Madonna attained its name when "two Italian stone masons" were hired by Miller to erect a life-size statue of the Virgin Mary, or the "Madonna," in memory of young Sarah—hence the name Mount Madonna. It is claimed that after the death of Miller in 1916, the statue was removed, and the vast property was donated to the county.

The stories of a girl dressed in white wandering throughout Mount Madonna County Park, walking along the lonely roadside after dark and toward the dangerous road ways of Hecker Pass, have become legendary.

In 2011, a hiker claimed to hear the heavy beats of a horse's hooves coming her way as she walked a hiking trail at Mount Madonna Park. Concerned that it could be a wild animal, she anxiously kept her dog by her side as she continued to hear the crashing of brush beneath heavy hooves get closer and closer. Yet nothing was there. Perplexed, she continued with her hike, wondering if she had just unwittingly had an encounter with young Sarah Miller riding her horse.

In February 2013, a woman recalled a camping trip with her family:

My family and I were camping at Mt. Madonna in 1985. I had driven from the campsite to the ranger station to use the payphone to call my boyfriend. I had 4 of my nieces and nephews with me and we all heard a woman screaming in the wooded area near by. I quickly hung up the phone gathered all the kids into my car and drove back to camp. I tracked down one of the rangers to report what we heard because I was afraid someone had taken a girl up there and was hurting her etc. They proceeded to explain that they get reports of that all the time and that they couldn't explain it. They would go check it out just to be sure, however when they get to that area, they are unable to find anything.

In an excerpt from the October 20, 2015 *Santa Cruz Sentinel*, Mount Madonna County Park ranger Eric Goodman recollected a chilling encounter while on duty. In a conversation later recounted by Samantha Clark, he claimed the following:

MOUNT MADONNA'S SARAH MILLER

A few people, unsolicited, said, "Have you seen a girl in old-fashioned dress looking for a ride?" said parks ranger Eric Goodman, who worked at Mount Madonna from 1980 to 1990. "I've heard that a few times. They went back and tried to find her."

Locals have told him that the ghost tries to leave the mountain in people's cars.

"One night I heard these kids talking, and there's a trail down below so I went and looked with my flashlight," Goodman recalled. "Then I heard 'Help me! Help me!' A couple times really loud."

He froze in his tracks and his heart started beating faster and louder. He of course, knew the story of Sarah. Then he heard it again, so he called for backup to search for a child possibly lost on the trail. "We looked all around and couldn't find anything," Goodman said. "It definitely gave me the heebie-jeebies."

Although Mount Madonna is known for its Native American history and haunting tales of Sarah Miller, this alone does not define the number of casualties that have left their ghostly impressions on this mountainous plateau. The feeling that Mount Madonna is haunted by a tortured past could be attributed to several different tragedies that have happened there. The following newspaper clippings represent just a few of these.

From an August 23, 1936 excerpt from the *Santa Cruz Sentinel*:

JACK BENNETT FOUND DEAD IN MT. MADONNA PARK
Killed Himself with Rifle Used in Slaying Victims

WATSONVILLE, Aug 22—Dead by his own hand, just as he threatened. Jack Bennett, 55 was found in his car in a secluded spot in the Mount Madonna park, near Hecker Pass, early this morning his head blown off with the same 30-30 rifle with which yesterday afternoon at 2:07 o'clock he killed Mrs. Grace Mae Ayers, 28 and her alleged paramour, Austin W. Martin, also 28, in what local police characterized as the most brutal, cold-blooded murder in the history of Santa Cruz County.

From the *Santa Cruz Sentinel* of August 12, 1938:

SKELETON FOUND MT. MADONNA NOT IDENTIFIED
Bones Found in Forest May Be Those
of Gus Hushbeck, Lost Watsonville Man

Authorities yesterday launched an investigation seeking to identify the skeleton of a man, found at the summit of Mt. Madonna just over the Santa Clara county line.

The skeleton apparently had lain in a small clearing surrounded by brush and redwoods for about five years. The find was made Wednesday afternoon by W.T. Walton and Steve Firebaugh of the Carlton district.

Walton said the skeleton was complete, and there was no evidence that the man, who had been about five feet 10 inches tall, had met with foul play. Only a few fragments' of clothing were found. Rotting shoes were still on the bones of the feet.

Authorities expressed belief the skeleton might be that of Gus Hushbeck, elderly Watsonville resident, who wandered away about five years ago, and was never seen again. A party of searchers traced him to Chittenden pass and then lost the trail.

From the *Santa Cruz Sentinel* of February, 6 1944:

WEEK-OLD MURDER BELIEVED SOLVED; THREE WATSONVILLE MEN
HELD FOR DEATH OF S.C. MAN
By Ray Ollestad

A murder mystery was unraveled in Santa Cruz County yesterday. Allegedly murdered sometime last Sunday afternoon was 43-year old Resituto Gonzules Tabares, Santa Cruz labor contractor and ex-school teacher, who lived on the Coast road near Walti-Schilling packing plant. His body was found in a bramble patch at the side of Mt. Madonna road.

From the *Santa Cruz Sentinel* of October 1, 1969:

WATSONVILLE MAN HELD FOR MURDER
Andra Morill, 20, Watsonville, is being held in Santa Clara County Jail for investigation of murder as prime suspect in the killing of an 18-year-old expectant mother last weekend near Mt. Madonna Park.
The girl, Sarah Chavarria, had the same Watsonville address as Morillo, Front St. She was found with her throat slashed Sunday.

From the *Santa Cruz Sentinel* of August 25, 1980:

Mount Madonna and the ghostly ruins of the Henry Miller estate, which still exist at the Mount Madonna County Park today. *Courtesy of SCGH, 2011.*

DATE SET ON YOUTHS' MURDER TRIAL
Four Watsonville teen-agers this morning were ordered to stand trial Oct. 20 on charges they murdered two 16-year-old youths last February on a remote mountainside near Mount Madonna Park.

Although Mount Madonna Park is a beautiful place for campers of all ages, for the select few, its beauty is exceeded by its mystery, for they are the chosen who have witnessed its haunting spirits firsthand. From hearing the fateful cries for help of a young woman's voice who is nowhere to be found to ghostly apparitions of a young girl in white wandering the treacherous roads and then disappearing, the thunderous sounds of stampeding hooves that leave ghostly prints in the dust and the phantom spirit of an Ohlone man that aimlessly wanders through its plateau. These are but a few of the tales that eyewitnesses have claimed to behold.

Is Mount Madonna a portal to the spirits whose tragic past has left an imprint on its mountainous landcape, or are the ghostly tales at Mount Madonna just that—tales woven around a flaming campfire to incite fear while roasting marshmallows on a moonlight night?

The Beating Heart of Brookdale Lodge

Nestled in the Santa Cruz Mountains in a town called Brookdale, among the redwoods and the sugar pine trees, lies a 150-year-old haunted historical lodge. Claimed to be erected on old Ohlone Native American land, the once World Famous Brookdale Lodge is stationed between the Boulder Creek Cemetery on its left and the Felton Cemetery on its right. Perched between the two in a triangular effect, the lodge is energized by an endlessly flowing spiritual as well as literal stream that runs through the center of its hull, fueling the San Lorenzo River. Harnessing the energies between both the living and the dead, this is the beating heart of the Brookdale Lodge.

The bar was filled to capacity on this night. Still, the jukebox played 1970s, '80s and early '90s renditions of old-time rock-and-roll. Spirits soared with laughter and drinks galore as patrons enjoyed one another's company on a festive Friday night. It was the first time that I had ever patronized the World Famous Brookdale Lodge, tucked back in the Santa Cruz Mountains near the flowing San Lorenzo River. The majestic gingerbread-style lodge was a breath of fresh air from the confines of the traditional Santa Cruz city pubs and the common urban lodging the city provided.

With the beautiful redwoods and sugar pines alike, the lodge's historical motif and legendary past were unfamiliar to me, as I had recently returned to my roots after a long absence. A creek runs through the center of its dining halls, making its way to the large San Lorenzo River. The mesmerizing

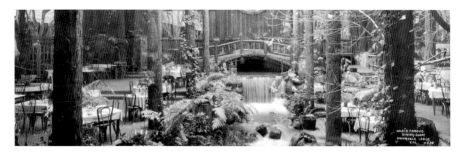

The World Famous Brookdale Lodge. The beating heart lies in the Brookroom. *Courtesy of Santa Cruz Museum of Art and History.*

setting was a treat to enjoy far from the hustle and bustle of the common metropolitan area.

As the midnight hour approached and the camaraderie continued among friends old and new, an eerie transformation filled the air, almost as if, for a moment, the world slowed down. Within moments, I took my attention away from my companions and the buzz that filled the room to notice a young girl not more than ten years of age wandering through the bar. She was adorned in a beige-colored dress that went past her knees, two French braids on each side of her head and something (perhaps a stuffed toy) clutched in her hands. She seemed to wander from table to table as if she was looking for someone, ignored by everyone she approached. The child moved to the adjacent table, where two couples were seated across from one another. The little girl stood behind a woman who was engaged in conversation and began tapping her on the shoulder from behind, as if she seemingly knew her or wanted to ask a question of her. I noticed the woman seemed to be blatantly ignoring the child, even shooing her away as if swatting at a fly.

"How rude," I thought to myself, wondering if the woman was this child's mother or other relation, seemingly oblivious to the child's need for attention. However, the woman continued to pay no mind and rubbed her shoulder in a manner as if she had gotten the chills. The young girl appeared unsurprised and even amused with her reaction. Still, questions entered my mind as to why there was a young child in a bar at nearly midnight and why no one seemed to take notice. Didn't anyone else find this odd?

As I continued to watch the young girl's movements, she got close enough that I felt the need to speak with her. "Are you okay honey, are you lost?" I asked. The child froze as she looked at me, like a deer caught in headlights, wide-eyed. Her eyes seemed to turn darker in color the longer she looked at me, staring as if frozen in time. She finally released her gaze and ran

out of the bar, down the hall, turning the doorknob and opening the glass door leading to the dining hall (known as the Brookroom), where the famous babbling brook runs through.

I finally turned to my friends and asked, "Did you see that little girl?" Of course not. They were completely oblivious to what I had witnessed and paid no mind to my concerns. An employee walked toward the bar, and I announced to her, "I think there is a lost little girl in there," pointing to the Brookroom. Perhaps she was a child of a guest, I thought to myself. The employee immediately inquisitively asked, "Little girl? What did she look like?" I gave her the description of the child in the beige-colored dress I had seen, and the employee inquired if I had ever heard of Sarah. I had no idea who she was talking about, as this was my first time at the Brookdale Lodge and I was unfamiliar of its guests. Nevertheless, I insisted that the little girl went into the dining hall. The employee went toward the glass double doors I mentioned, both of which were locked, as the dining area was shut down for the evening. She proceeded to ask how the girl could have gone through the door. I thought perhaps the woman must be a bit daft, as I explained that the child opened the door. How else would she get in the other room? However, as the employee checked the double doors, she was unable to open them. The deadbolt above was securely locked. I insisted that the child had opened the door and gone in. The employee hurriedly attained the key from the lobby and unlocked the doors to examine the dining hall with the creek. No little girl was reported to be seen.

Upon returning and once again securing the Brookroom doors, the employee said to her coworker, "She saw Sarah." I didn't think further of the situation and decided that the child must have been a familiar guest of the hotel who made her way back to her guestroom through a dining hall exit. Case closed.

It wasn't until much later, when I learned of the Brookdale Lodge's haunted historic past and the story of Sarah Logan, that I realized my experience was much more than that of a wandering hotel guest, exploring its halls.

BROOKDALE'S BEGINNINGS

The year was 1890. Judge James Harvey Logan was a former district attorney and an experienced botanist responsible for the creation of the loganberry. He had become a Santa Cruz Superior Court judge and president of the

Bank of Santa Cruz and Loan. Adding to his successes, Logan continued to accumulate wealth by acquiring the usage rights to the Grover Mill lumberyard, located in Brookdale, as well as purchasing an additional 325 acres of acreage in the same area. As a result, Logan became known as the founding father of Brookdale.

Logan had monetary interests in the mill, the Brookdale Land Company, nearby electric and water plants and the development of local stores and the beginnings of a Brookdale Hotel located near Clear Creek. With these vested interests, Logan monopolized the small town of Brookdale. Adored and well respected by the mountain community, Logan created an abundance of jobs not only for the local residents but also for those willing to commute from the county of Alameda, where Logan's family roots still existed.

The nearby logging mill and hotel construction provided jobs for hundreds of workers, many of whom set up camps and makeshift cabins all along the beautiful redwood forest. Families often joined their men during the summer seasons and beyond. The women cooked and washed and mended clothes. A large tent sufficed as a makeshift school for the children who accompanied them. A community was born.

By 1890, Judge Logan was at the peak of his political career, appointed as a member of the Breakwater Committee to create a proposal for the national government that involved the ascertainment of statistics and acquisitions of imports and exports for the local harbor and future land development. He sat among the city's most prominent founders. With Logan's connections, he also finagled Ordinance No. 246, which assigned him privileges as an associative partner, giving him franchise and operating rights of the Electric Street Railway Company in Santa Cruz. Due to Logan's prominent stature, he was soon nominated for city mayor, a candidacy he declined.

By 1891, Logan had become a nominee in the city's centennial election celebration as president of the settlement of the city, an honor only bestowed on an elite few. Logan continued with his financial acquisitions, purchasing 116 shares of controlling interest of the *Surf*, a local newspaper editorial firm. With his continued presidential ties to Santa Cruz Bank and Loan, along with the help of banking partner William T. Jeter (also a state governor selectee), Logan took possession of numerous bank foreclosures, adding to his vast financial assets.

With Logan's continued developmental interest in Brookdale and control of a granite quarry, he moved on to create new roadways in the mountainous regions of Brookdale, benefiting not only his own homestead in the local sense but also the lives of those who lived in the province.

He later announced the connection of a city water system to the "people of the hills," allowing for improved water pressure like those in the city's business sections.

By early 1892, rumors had surfaced that County Circuit judge J.H. Logan was being nominated for the Superior Court of Santa Cruz; according to his political cohorts, he was a shoe-in for the position. Logan continued to attain land and purchased an additional five hundred acres in Watsonville near his Logan Berry Ranch for further farming ventures. He sponsored countless charitable events in the area and gave generous donations to those in the community, particularly those of the Republican Party persuasion. In the fall of 1893, Major Frank McLaughlin received a private telegram from the governor's office that noted Logan's appointment as Superior Court judge of Santa Cruz County and successor to Judge McCann.

Although Judge J.H. Logan was a prominent member of society in the Santa Cruz area, he was not without his share of enemies. As Superior Court judge, Logan sent not only many accused criminals to the confines of San Quentin State Penitentiary but also scores of others to meet their makers on the gallows at the end of Death Row. However, the criminals who detested Logan as he slammed his gavel down and rendered life-altering sentences were not the only ones of the populace who despised him. There was also the working-class citizen who perhaps may have been down on his or her luck for whatever reason and lost their home, land, business or livestock to the bank (of which Logan was president). Adding insult to injury, those people's properties were typically purchased by Logan in a foreclosure sale at a sheriff's price.

In 1869, in front of the postal telegraph office on Pacific Avenue and Church Street, a woman by the name of Mrs. Catherine McKenzie struck at the judge with a horsewhip. As the whip descended, the judge grabbed Mrs. McKenzie's wrist before it was able to make contact with his skin and proceeded to detain her until the arrival of the constable, who took her into custody. Mrs. McKenzie explained that her aggravation with the judge had been ongoing after he testified against a mutual friend, using what she felt was his judicial influence to sway Judge Breen. To make matters worse, Mrs. McKenzie felt that Judge Logan contributed to the lengthy civil suit that ultimately resulted in the loss and foreclosure of property owned by her brother and herself.

However, this was a small accusation compared to what was soon to be known as one of the biggest scandals in Santa Cruz history: Judge Logan was named as a conspirator in an ongoing litigation filed by L.F. Grover

over the acquisition of Grover Mill Lumber in Brookdale. Charges of fraud and conspiracy against the Bank of Santa Cruz and Santa Cruz Loan and Savings were made against him and former lieutenant governor William T. Jeter. In Grover's allegations, he stated that a transaction had been agreed on with the Santa Cruz Bank and Loan over the indebtedness of Grover Mill Lumber amounting to $40,000, in which Grover received nothing in return. L.F. Grover provided notes exceeding $30,000 that had never been accredited, proving the indebtedness, which dated back to June 1897, when the company was insolvent and released by the bank (which Jeter was president of at this time).

Grover also continued in his lawsuit, stating former governor Jeter, Judge Logan and MaKinney (Jeter's associate and the bank attorney) conspired to set up a board of dummy directors that they were privy to and that both Logan and MaKinney were tools in the conspiracy, using their legal influence and expertise to doctor documents and withhold holdings of Grover Mill Lumber for personal enrichment. The sensational case made headlines in December 1900, sending the people of Santa Cruz up in arms, as three of the most affluent members of the community were thought frauds. The scandal lasted for years in the judicial courts. During this time, Judge Logan was nearing reelection as Superior Court judge; he later dropped from the electoral race, his reputation stained.

On July 13, 1909, misfortune continued to follow Judge Logan when gloom befell the Logans' Brookdale home. "The Chateau," as it was called, was shadowed with death, as the lady of the manor, Mrs. Catherine Logan, passed away, succumbing to a two-year illness, as noted by the July 14, 1909 *Santa Cruz Sentinel*:

DEATH OF MRS. JAMES LOGAN

Mrs. Catherine Logan, wife of Judge James H. Logan, died at her home in Brookdale Tuesday morning, from the ravages of Bright's disease, from which she had suffered for some time. The deceased resided in this county for over forty years, and was a true and loving wife and a lady of many estimable qualities. Besides her husband, the Judge, she leaves two sisters in Montreal, Canada, and a sister and niece in Santa Cruz; besides a host of friends to mourn her loss.

However, the judge seemed to quickly recover from the loss of his wife, and what could be considered as a rather questionable affair soon became

public knowledge. On August 1, 1910, a year after the death of Judge Logan's wife, to the surprise of the community, it was announced that the judge had remarried. At the home of his bride's parents, the sixty-nine-year-old Logan married his stenographer, Mary Elizabeth Cousons. The bride, who was believed to be forty-four years younger than her husband, was said to be possessed of considerable beauty. The marriage was kept a secret and then released after the couple traveled north for their honeymoon.

In 1911, Judge Logan was mentioned in multiple litigation processes regarding the properties in Brookdale. On February 23, 1911, it was announced that Logan had sold the Brookdale land to attorney and president of the Santa Cruz Emporium W.M. Aydelotte. Aydelotte had purchased not only the Brookdale Hotel and the equipment it housed but also the "Chateau" property, the Cuckoo Cottage, the Rose Cottage, the Brookdale Store, the dance hall and the stables. His intended aspirations were to double the size of the store, enlarge the dance hall and add a second story to the Brookdale Hotel. Aydelotte, who owned his own carbonating machine and had been carbonating the Clear Creek mountain water into soda for some time now, also aspired to install an ice plant and manufacture his own ice cream.

Judge Logan continued to maintain ownership of the Brookdale Water and Electric Plant, as well as the post office. However, Logan's future endeavors no longer included prospects in Santa Cruz. This same year, his new young bride gave birth to a daughter named Gladys. Finally, in October 1911, Judge Logan uprooted the trio and retired to the Alameda County area. He passed away seventeen years later in 1928 at the age of eighty-six.

THE LEGEND OF SARAH LOGAN

Although Judge Logan suffered many tragedies at Brookdale, it is not his spirit that guests have witnessed wandering Brookdale's halls. One of the most famed encounters at the Brookdale Lodge is that of little Sarah Logan, a child who, according to legend, drowned in Clear Creek and was believed to be the niece of Judge James Harvey Logan. However, the legend has gone without merit to substantiate its claims and cannot even confirm that Judge Logan had a niece by the name of Sarah. Although many historians and researchers have searched Santa Cruz records in a quest to unravel the famous legend of Sarah Logan, none have succeeded.

Imagine if you will the year 1892. Judge James Harvey Logan was at the peak of his political career and running for Supreme Court judge of Santa Cruz—a nomination not to be taken lightly and a position held with such high regard as to not withstand a tarnished reputation of even the smallest proportion.

While Logan's political campaign was underway, his Brookdale Hotel development was also in full swing, and work was abundant with the nearby Grover Mill Lumber Camp. Many settlers began traveling from the nearby Alameda area with their families to partake in the employment offered, including that of John and Sarah Logan and their ten-year-old daughter named after her mother. Although perhaps not directly related to Judge Logan (John, in fact, shared his brother's first name), on location of the Brookdale site, John was often mistakenly thought to be directly related to the founding father.

Little Sarah Logan, with her long dirty-blond hair often adorned in pigtails and almond-colored eyes, enjoyed romping through the woods of Brookdale, as there were plenty of children to play with by her side. Her whimsical crooked smile always grinning on her face, she was a child filled with happiness. The mountainous range of Brookdale and Clear Creek became her playground, one that filled her with imagination, where anything was possible. Often Sarah would play hide-and-seek with her peers, ducking in and out of the 1870s log cabin that Judge Logan had built, sneaking about, hoping not to be discovered, hiding behind trees and giggling as the seeker unknowingly passed her by. Sarah would then teasingly come up from behind them, tap their shoulder and once again run out of sight, egging on a game of tag. Brookdale was little Sarah's imaginary oasis, filled with her happiest memories.

However, in October 1892, as Sarah went outdoors to play even in the cool fall months of October, this day would end very differently than those preceding it. As the Logan family packed their camp up, preparing to head back to Alameda before the onset of the winter weather, Sarah continued with her reckless play around Clear Creek, not wanting to leave. Running from her annoyed nanny, who was chasing her about yelling, "Sarah, come now. It's time to go!," she continued to giggle in a game of "catch me if you can" as she veered dangerously close to the sloping embankment of the creek. The nanny, tiring of this game, once again yelled, "Sarah!" Before she could get out the word "Stop," the child suddenly slipped off the bank and tumbled to the rocks and flowing waters below. Hitting her head on a rock during the fall, Sarah, dazed and confused, began swallowing water with every panicked breath.

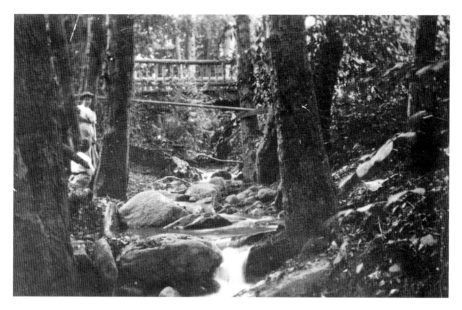

Clear Creek, Brookdale, circa 1900s. *Courtesy of Santa Cruz Museum of Art and History.*

The nanny, thinking quickly, raced down a premade path that led to the waters below and was able to grab Sarah just in the nick of time. "Help! Help us!" the nanny screamed as she held Sarah in her arms at the bottom of the creek, unable to climb back up with the little girl. Sarah was cold and wet and began to cough up water, gasping for air. With a huge bloody gash on the back of her head, the child barely escaped death. Sarah's father, John, and mother, Sarah, who were waiting by the wagon, heard the nanny's cries for help and came running. Uncertain of the seriousness of the fall, her mother took shivering little Sarah under the safety of their covered wagon and removed her wet clothes, warming her with blankets. She tended to the bloody gash on her head. The family hurriedly proceeded to their Alameda homestead and the aid of their hometown doctor.

Over the next few days, Sarah seemed to worsen. She slept most of the time, vomited often and did not seem to be aware of where she was. The doctor visiting their home surmised that she suffered a severe concussion and possible skull fracture. Her prognosis was uncertain. Over the next few weeks, young Sarah's health continued to decline. She began to develop a lung infection, accompanied by a high fever. In and out of consciousness, she rambled nonsensical yarns of still playing among friends at Brookdale.

On November 6, 1892, ten-year-old Sarah Logan was pronounced dead. Diphtheria was noted as the ailment that plagued her, and paralysis of the lungs was the immediate cause of death. Although this tale is principally the author's theoretical rendition, it is based on the discovery of a death certificate found not in the county of Santa Cruz but rather in Alameda. To date, this is the only proof of the existence of the life and death of Sarah Logan. This death certificate is the only historical verification that the legend of Sarah Logan may ring true; it fits the time period, the namesakes and the county to which the Logan family had ties.

Is Sarah Logan's soul trapped at the Brookdale Lodge, returning to her fondest memories in life, unaware that she has long since passed? Did she never realize that on that fateful October morning more than 120 years ago, she and her family had left Brookdale and returned to their homestead in Alameda, where she died? Her soul continues to aimlessly search for her family, a lost little girl roaming the corridors of the Brookdale Lodge along with other restless spirits, forever caught in its primordial hold. Many believe this to be true.

Brookdale's Numerous Drownings and Accidents

The Brookdale Hotel was, by far, the most popular summer hot spot in the region, with travelers coming from all over to enjoy the giant redwoods and riverside swimming holes and reserve their favorite cottage. There seemed to be no end to the recreational summer bliss. However, the enjoyable waters of Brookdale were not without their dangers.

In July 1910, a Berkeley maid vacationing in Brookdale was bathing in the creek's waters when she attempted to cross a deep section of the swimming hole; she fearfully lost her courage, fell into the deeper parts of the waters and began sinking to the bottom. A nearby guest saw the event and quickly reacted, swimming into the waters, grabbing the maid by the hair and saving her life, pulling her to the riverbank.

In July 1911, two Alameda County high school girls who were guests at the Brookdale Hotel went wading in the waters and inadvertently began floating farther and farther away from the shallow swimming hole. They soon reached waters that were beyond their depths. Upon realizing that they could not touch the sandy bottom, the girls panicked, holding onto each other and sinking to the bottom. William High of Oakland saw the girls and dove in after them, safely bringing them to shore.

Throughout the years, multiple near deaths and fatal drownings have occurred in the waters of the Brookdale Hotel's swimming areas. However, none was as tragic as the triple drowning in 1912, when three Oakland women drowned in the waters at a local swimming hole. Thirty-year-old Mrs. Cripps, the wife of a tea and coffee expert, along with Ms. Hawkett and Ms. McDonald, both sixteen years of age, from Oakland, were residing at one of the local Brookdale Lodge cottages. The girls, adorned in their bathing suits, entered the local public swimming hole at Brookdale. After a while, the pair decided that they would like to bathe somewhere a little more secluded, and the entire party moved downstream. Mrs. Cripps walked along the banks with her two children in tow, four-year-old William and eight-year-old Dorothy, while the two sixteen-year-old girls walked along the bed of the flowing stream. Suddenly, the girls stepped off a shelf on the bank into a pool that was at least fifteen feet deep; unable to swim, the girls panicked and quickly began to sink.

Meanwhile, Mrs. Cripps, watching from the bank as the two girls fought for their lives, hesitated. She yelled at her two small children to stay on the bank, reluctant to leave her two young children alone yet not able to stand by and watch her terrified wards drown as they screamed for help. She plunged into the body of water after the two teenagers; however, Mrs. Cripps's efforts were to no avail, as she could not swim either.

The two children bore witness to the sight before them, running up and down the river's edge, screaming and crying for their mother. Rescuers soon heard the children's cries and came to their aid. However, it was already too late. Although the rescuers were able to retrieve the three bodies from the waters, their attempts to revive them were futile, as all three women had perished.

In October 1935, the waters of Clear Creek's pools claimed another victim, this time a nineteen-year-old Chinese girl who went wading. Adorned in a white swimming gown, the girl presumably lost her footing in the eight-foot depths and sank to the bottom, unable to resurface. Luise Chinn was a servant for a well-to-do San Francisco family. The family grew concerned when the girl did not meet them for breakfast. Upon searching for her, her body was discovered floating in the swimming hole. She was dragged ashore, but she was beyond saving.

The many deaths have not dissuaded visitors, who have seemingly been summoned by the lodge's alluring grandeur. Many surmise that the cursed waters of the San Lorenzo River, which fed Clear Creek and ran through the walls of the lodge, were literally consuming victims and harnessing their life force within its walls—a life force that acts as the beating heart of the Brookdale Lodge.

Brookdale's Prohibition Era and Gangsters

In 1924, physician and Methodist preacher Dr. Foster Kendrick Camp purchased the Brookdale Hotel, removing many of the old cottages and outbuildings. He then created a newly functional, more desirable hotel dormitory with more than forty additional guestrooms and more than half a dozen cabin retreats. He also added a large upscale dining facility that allowed the waters of Clear Creek to run through it, officially named the Brookroom. Dr. Camp's vision was to bring nature's beauty indoors for all to enjoy. Dr. Camp employed the architectural genius of Horrace Cotton to transform his vision into a reality. And that he did, with the majestic babbling brook and plumage adorned throughout. The magnificent Brookroom was unlike anything the world had ever seen before. Through word of mouth, people soon began to travel from all over the globe for a chance to dine and lodge at this deluxe mountain getaway, now officially named the World Famous Brookdale Lodge.

Dr. Camp took extreme pleasure caring for guests from all walks of life. However, his strict Methodist values made him a very devote prohibitionist, and although his guests were free to enjoy everything the lodge had to offer, Dr. Camp enforced a very strict rule against consuming alcoholic beverages at his exquisite retreat. Dr. Camp was so adamant about his policy that he literally would walk about smelling his patron's drinks, and those that smelled of the sinful intoxicating inebriant, likely from a smuggled flask, would immediately be poured out and exchanged for a fresh glass of carbonated soda water.

However, this did not stop guests from flocking to the Brookdale Lodge. Even President Herbert Hoover himself often stayed at the famed lodge, toting his fishing pole in one hand and a smoldering cigar in the other. The famed president would perch himself on the honeymoon bridge in the Brookroom and cast his line in the creek below for a freshly caught trout dinner, happily cooked to perfection by the house chef. The World Famous Brookdale Lodge lured guests from as far as China to Germany and Cairo, Egypt. Its majestic flowing stream like an enchanted spell, the Brookdale Lodge seemed to invoke a bewitching reverence.

Dr. Camp did not simply take advantage of the riches the lodge provided. He often held special benefit diners and dances with a live multi-instrument orchestra. As a physician, Dr. Camp was devoted to the Shriners Hospital in San Francisco, and because of this, he had a wishing well built on the lodge premises known as the "Wishing Well for Crippled Children." Each year,

Dr. Camp would hold an annual fundraising event, and the monies retrieved from the well would be counted and then donated to the Shriners Hospital; an average year often could yield between $350 and $400.

However, the lodge was not without its snags. Only one year after the purchase and creation of the magnificent Brookdale Lodge and the exquisite Brookroom, a fire broke out in the dining room in May 1925, threatening to destroy the hostelry. Firefighters from Ben Lomond and Boulder Creek were able to contain the fire before it consumed the lodge. The cause of the fire was uncertain and resulted in damage of 25 percent of the structure. However, that did not deter Dr. Camp. Grateful for the quick response by firefighters, he publically honored their efforts and immediately began repairs. The lodge quickly resumed catering to guests.

As the fame of the lodge grew, so did its clientele, catering to dignitaries and Hollywood elite alike. Chief Justice of the U.S. Supreme Court Harlan Stone, James Dean, Hedy Lamar, Cordell Tull, Shirley Temple, Rita Hayworth, Joan Crawford, Marilyn Monroe, Joe DiMaggio, Howard Hughes, Bob Hope, Henry Ford and many more graced the World Famous Brookdale Lodge with their presence.

The lodge even catered to well-known servicemen such as Lieutenant Commander Stanley M. Haught, former commander of the USS *Alden* who, in 1938, brought with him to share at the Brookdale Lodge the only colored moving picture film of the last few minutes of the ill-fated shipwreck of the celebrated USS *Hover*, foundering on the rocks during its last sea voyage off the coast of the Formosa Islands.

In addition to Commander Haught's visit, four visiting airmen who were stationed aboard the naval destroyer USS *Colorado* joined around a table at the illustrious event and shared a tale of remembrance of Captain Fred Noonan, the flight navigator of Amelia Earhart's plane, which was lost at sea in 1937 while en route from Lae, New Guinea, to Howland Island. The four airmen were a part of the search and recovery efforts; however, Amelia Earhart's plane was never found and was presumed lost at sea.

Despite the nonalcoholic environs, which Dr. Camp diligently tried to enforce, the Brookdale Lodge still attracted a large number of seedy characters. As everyone knew during the 1920s through 1940s, where there was money, there were gangsters. So it comes as no surprise that they, too, frequented the Brookdale Lodge. With Prohibition on the rise, the lodge's vast array of underground tunnels and corridors—leading from beneath the underbelly of the lodge itself and discreetly to the roadside—made the location an irresistible hotspot of illegal activity; it might well go unnoticed

and invited a new safe haven for none other than notorious mobster Al Capone. Capone's organized crime syndicate had factions throughout the United States. After Capone was captured, sentenced to Alcatraz and died in 1947, the nearby San Francisco organized crime syndicate blossomed and reigned well past the 1960s, with Jimmy "the Hat" Lanza the leading crime boss at the helm.

It goes without saying that even a devote Seventh-Day Adventist Methodist preacher like Dr. Camp was not about to go up against the infamous Al Capone and his band of wise guys. And where better to conduct illegal bootlegging but under the aegis of a dry lodge run by a Methodist preacher in the middle of the woods. The whispered rumors of the notorious Capone and his gang of cronies conducting illegal business beneath the lodge are legendary. The notion that his men dug out additional rooms and tunnels away from prying eyes has led to rumors of numerous bodies being buried beneath the catacombs of the lodge. The remains of rival mobsters, betraying stoolies and unruly prostitutes who had the misfortune of crossing the path of an unforgiving "boss man" or his henchmen are said to remain entombed in the bowels of the Brookdale Lodge.

By 1945, Dr. F.K. Camp had sold the Brookdale Lodge to another aspiring owner by the name of Cook. Hence it no longer was a dry resort filled with soda water and virgin cocktails but rather a fully functioning lounge filled with spirits for all to indulge. Between the 1950s and the '60s, the World Famous Brookdale Lodge continued earning its name after going through several more renovations and yet another new owner by the name of Barney Morrow.

DARK FORCES AT WORK ON THE BROOKDALE LODGE

In October 1956, a dark day loomed over the lodge, as flames began licking the nightly skies and smoke rose from its hull. The World Famous Lodge was virtually destroyed, ravaged by fire in the wee hours of October 23. It took seventeen fire trucks from different parts of the Santa Cruz region, including two from Santa Clara, and hundreds of firemen, who worked endlessly throughout the night to try to contain the blaze. Although no injuries occurred as a result of the inferno, the damage sustained to the luxurious lodge was estimated to be more than $250,000; the cause of the blaze was undetermined.

This did not dissuade lodge owner Barney Morrow. Reconstruction of the lodge was soon underway, and a portion was completed well enough to conduct business again. By 1960, the entire lodge was fully functioning, having had a complete facelift. Adorned with a new façade, the Brookdale Lodge looked as if it came out of a Swiss Alps frontier mountain village, along with a lovely wedding chapel that looked like something out of Neverland. The Brookdale Lodge's new interior makeover was soon also completed, with a new cocktail lounge designed to resemble an old Brookdale Railway station, additional fireplaces and balconies overlooking the creek in the Brookroom, as well as a game room for children, a TV and writing room, a wine and root cellar built underneath the stream and a heated indoor eighty-five-thousand-gallon swimming pool (equipped with a four-inch-thick plate glass observation window named the Mermaid Room). The magical design of the lodge's new façade came from the creative genius of its planner, Ted Duro, a former set designer with MGM in Hollywood who worked on such sets as *David Copperfield*, *Mutiny on the Bounty* and *Tugboat Annie*. The new World Famous Brookdale Lodge had risen from the ashes.

The Brookdale Lodge's fame continued to soar, and with the many rich and famous who continued to patronize its exquisite locale, so, too, did those whose statures was not as desirable. By the 1960s, the Mermaid Room was in full swing, stationed in the cocktail lounge with a glass observation wall looking into the pool. It became a weekend sensation for the gentlemen. Each weekend, three lovely ladies decorated in brightly colored mermaid attire would perform a watery acrobatic performance unlike any other. As the three enchantresses seductively danced, the highest-bidding gentleman suitor was able to win the company of one of the fair maidens in his private bedroom suite. A total of nine lovely ladies would perform three shows each weekend, making for nine rather happy gentlemen lodgers. Although

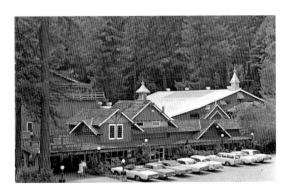

The World Famous Brookdale Lodge, risen from the ashes. *Courtesy of Santa Cruz Museum of Art and History.*

prostitution was something of an unmentionable norm in the lodge's heyday, so were other forms of dark behavior.

Alas, despite the happy memories of the many who left an imprint that resonates throughout the walls of the Brookdale Lodge, the essence of the lodge seemingly began to take on a life of its own. As the babbling waters of the Brookroom flowed, its energy ostensibly imprinted an unusual life force within, and when the parties were over and the doors closed for the night, a dark and ominous presence began to loom within its walls.

The Brookdale Lodge is believed to harvest both negative and positive energy, its stream a conduit for both worlds. Although the newest renovations of the Brookdale Lodge were certainly crowd pleasers, something seemed to be amiss with the once world-famous lodge. A darkness seemed to overshadow it. With the many deaths that surround the Brookdale Lodge dating back into its history, from drownings to mobsters to even an unsolved murderous tale in 1962 in which a thirty-seven-year-old Golden Gloves Boxing Champion by the name of Gil Mojica was found dead, the death toll continued, as if the lodge was harvesting souls.

It was like any other day for Gil and Joyce Mojica. Joyce was finishing up her 12:00 p.m. shift at the cocktail bar at the lodge. On this day, her husband, Gil, went to Boulder Creek to catch a movie and then returned to the lodge, like he routinely did many times before, to pick up Joyce. Gil sat and watched sports in the TV room, engaged in conversation with friends and lodge employees alike as he patiently waited for Joyce's shift to end.

Gil Mojica was an amateur heavyweight fighter who began his career in Eureka, California, in 1943. After he won three fights by knockout, he turned pro and continued his fighting career in San Francisco, winning another six bouts and becoming Golden Gloves champion. Mojica retired from boxing to pursue a career as a San Francisco police officer, where he served ten years before retiring from the force and settling in the Felton area, where he became a bill collector in San Jose.

However, on the afternoon of January 29, 1962, a puzzling chain of events occurred that resulted in murder. After Gil enjoyed a cup of coffee and continued socializing with employees, he was seen heading for the main lobby, with no indication given for why he was leaving. What occurred next is uncertain.

Several minutes after Gil had apparently left the lobby of the Brookdale Lodge, a neighbor in her nearby cabin heard four shots ring out from outside. Deputies arrived on location around the bend from the lodge and

found Gil Mojica sprawled alongside his vehicle; he had been shot four times by a .32-caliber gun—three times in the head and once in the neck, all fatal wounds. According to the sheriff's report, deputies uncovered three cartridge cases and one bullet, found near the vehicle, but a thorough search of the scene turned up no weapon.

Mrs. Joyce Mojica learned of the death after a busboy from the lodge left work and saw a red and white station wagon, sheriff's car and ambulance at the murder scene. He thought it was Mojica's vehicle and returned to the lodge to tell Mrs. Mojica. At first, she dismissed the idea, telling the boy that her husband was in the lobby watching television, like he usually did while he was waiting. However, she checked and found him gone. Their station wagon was missing from the lot. Another employee took her to the scene, where she learned of the murder.

Sadly, police never established a motive and were not able to piece together why Gil Mojica would have been possessed to suddenly leave the confines of the lobby and drive away. Police thought that perhaps he may have had enemies from his boxing or law enforcement days, perhaps even related to a crime syndicate; however, a background search revealed no clues.

This was only the start of the dark days that would continue to befall the Brookdale Lodge. On September 20, 1962, a civil action was filed against lodge owner Barney Morrow by the Brookdale Lodge Company, charging him with mismanagement of funds, selling of stocks and fraud. It would seem that history was beginning to repeat itself from Judge Logan's legal plights more than sixty years earlier.

As the ambience of the lodge seemed to change, so did its ownership. In 1964, San Francisco Trustees, with investment interests in the lodge, forced it into bankruptcy. The lodge would once again sell at a fraction of its estimated worth and become a shell of its former self. But with the changes arising, there was also an aura of negative energy that seemed to continue to breed.

On November 11, 1965, sixty-eight-year-old David J. Robenborn was shot to death in his living quarters at the Redwood Resort in Boulder Creek. His slayer was thought to be a guest of the resort and even ordered Robenborn's forty-year-old daughter, Elizabeth, out of her bed to look at her father's dead body. Elizabeth ran toward the door to escape, but the assailant shot at her, missing. The killer then shot again, this time hitting her in the shoulder. Elizabeth escaped from the house and hid from the killer before seeking help. Sheriff's deputies launched a search for the suspect,

identified as Robert Thomas Carona, a dishwasher at the Brookdale Lodge. Carona did, in fact, show up at the Brookdale Lodge a few minutes after the shooting and went into the cabin of a co-worker. A door-to-door search for Carona by police ensued.

In 1966, another fire broke out in the kitchen of the Brookdale Lodge. Four fire trucks from Boulder Creek arrived on the scene, although the damage in the kitchen was extensive. The fire was contained before escaping to the famous dining room.

In April 1970, the body of thirty-five-year-old Floridian Robert D. Ashley was found in his car. His vehicle was found off Clear Creek Road at the Brookdale Lodge; it was an apparent suicide, as noted in the cause of death. The coroner's office believed that Ashley's remains had gone unnoticed in his vehicle since at least mid-March. Ashley was described as unemployed and lived at the Brookdale Lodge.

The energy of the Brookdale Lodge had seemingly continued to awaken a madness that seemed to afflict the weak of mind. In March 1970, a drugged-out twenty-nine-year-old man by the name of Collins was booked into Santa Cruz County Jail on charges of assault with intent to commit murder. The suspect entered into a Brookdale Lodge apartment occupied by four women and two men, where he began clubbing the tenants with a shotgun. Witnesses said that Collin spoke in a normal voice when he first entered the room, stating, "I am going to kill all of you and then kill myself." Accordingly, he went berserk as if possessed and began beating the six occupants with the butt of the gun.

The allure of the lodge continued to summon the souls of the living. In April 1971, the body of a seventy-eight-year-old missing San Lorenzo Valley man who seemed to have wandered away from his home was found at Clear Creek behind the Brookdale Lodge; foul play was not thought to be a factor.

In 1992, another seemingly challenged soul was summoned to the lodge. A sixty-eight-year-old mentally ill woman went missing over the weekend. According to her therapist, she was found at the Brookdale Lodge. It would seem that the woman, "Maria," walked away from a board and care facility in Santa Cruz. Her photo was published in the local newspaper, and a clerk who worked at the Brookdale Lodge recognized her as a registered guest. The woman's identity was confirmed as that of the missing woman, and she was safely returned to the care facility. The missing woman was a self-proclaimed psychic and claimed to have "friends," presumably of the ghostly sort, that she wished to visit at the Brookdale Lodge. The woman was known to not have any relations in the mountainous area.

Natural disasters were another calamity that plagued the Brookdale Lodge. In December 1975, rains amounting to thirty-three inches in depth in much of the Santa Cruz Mountains caused massive flooding, raising Clear Creek to enormous heights. The torrential waters consumed three hundred tables and chairs from the Brookroom, washing them down the creek to the waters of the adjoining San Lorenzo River and toward the sea.

But alas, the floodwaters soon struck again. In January 1982, a three-day torrential rainstorm hit the county of Santa Cruz, filling up the San Lorenzo River and connecting creeks and streams. The waters of Clear Creek reached monumental proportions, dragging along with them tables, chairs, tree branches, mud and various debris as they tore through the lodge into the streets and down the river. The flood caused an estimated $1 million in damage. However, this was only part of its wake, as downstream in the neighboring town of Ben Lomond the raging floodwaters pounded nearby Love Creek. The torrential waters caused massive mudslides, killing a total of ten men, women and children as they slept. It would become known as one of the worst mudslides in California history.

Several months later, the World Famous Brookdale Lodge once again reopened. In September 1982, tragedy struck the lodge as another fire ravaged the Brookdale Lodge, this time hitting the famed Neverland-style chapel built by Barney Morrow. The chapel had held thousands of wedding ceremonies from around the world yet was completely destroyed—a historic piece of the lodge's history left in rubble and ash, presumably set ablaze by arson.

In August 1983, a bomb went off behind the World Famous Brookdale Lodge, strapped to a main gas line near an electrical pole and fashioned out of a plastic garbage bag, a book of matches, tape and gunpowder. Although loud, the explosion resulted in no injuries or damages. The deafening blast was heard in both the neighboring towns of Boulder Creek and Ben Lomond. It would appear that the World Famous Brookdale Lodge had an enemy.

By the mid-1980s and 1990s, word had begun to spread that the Brookdale Lodge was haunted. Employees began noticing strange occurrences at the lodge, particularly during hours when the lodge doors were closed to the public. The feeling of an unnatural presence began to cast a dark shadow over the lodge's ambiance. Those who spent much of their time at the lodge soon began to become aware of a presence that they could feel but not see.

With tales of the lights turning on and off in the wee hours of the night; the jukebox suddenly bellowing a jovial tune, breaking the silence in the

stale air; and dishes being thrown from their perch, the lodge seemingly had come alive. But these weren't the only observances people claimed to have experienced. While all would be quiet, the sounds of voices laughing, sometimes even arguing, could be heard, yet no one was about. While using the bathrooms, the sound of a child giggling could be heard, and the toilet paper would begin to unravel and pile on the floor from its roller, leaving its user running from the stall a pasty pale white as they fled.

Shadowy figures can be seen wandering in the dimly lit lounge, and a cool rush of air would often breeze by an unsuspecting warm body, leaving one riddled with goose bumps, as if they had been touched by death. The World Famous Brookdale Lodge is haunted. The babbling brook of Clear Creek beats like a heart through its massive hull, harnessing the energy of both the living and the dead. The lodge lives with the souls of its checkered past. Thought to be a portal of mass proportion, the experiences shared by the living continue to manifest alongside those of the dead.

Testimonials

In 1992, Deena Smith was a resident in the upstairs apartment complex near the Brookdale Lodge swimming pool along with her three young children. Smith reported, "Every night there would be pushing on the edge of my bed as if someone was trying to get my attention, and each time during the night, I would turn on the bathroom lights and each time I did so, the lights would instantly turn off. My husband, Pat, at the time, tired of complaining to the front desk, assumed it was the breaker and would walk down the dark cat walk to flip the switch off and on to our room. He always said the hair on the back of his neck would stand straight up. This happened routinely. On one occasion, my neighbor Carol, who resided in a downstairs unit, came to visit, and while we sat in the living room, she observed the ghostly apparition of a little girl, sitting on the step in my bedroom, a little girl that she believed to be Sarah Logan."

Deena Smith's daughter, Ashley Hernandez, now age twenty-seven, recalled an encounter with someone she believes was little Sarah Logan: "I had to be at least 13 or so. We went to go swimming at the Brookdale Lodge pool, with Mama, Creig and my younger siblings. It was the first time I ever went swimming at the lodge. I remember being nervous and worried

about people seeing me swim on the other side of the big glass window, but Mama assured me that this part of the lodge was closed, which it was. The entryway to the Mermaid Room was roped or chained off, so people could not enter; they were finishing a remodel of that part of the hotel. I recall while in the swimming pool I wanted to double check, so I swam to the very bottom of the pool and put my hands around my eyes to look through the glass. I saw a figure of a little girl on the opposite side of the glass. It freaked me out because of the way she was facing; it was at an angle, and it made it look like she was looking right at me. She began almost pacing back and forth. It was really weird because it seemed like I could almost see directly behind her; it was almost like a moving picture."

Sarah is known for pulling pranks on people at the lodge. As a playful spirit, like any other child, she tries to get the attention of anyone who will listen.

Former Brookdale Lodge employee PATRICIA ROTHFUSS recollected a recurring incident at the bathrooms near the bar: "I worked at the Lodge in 2008 as a bartender. While on my shift I recall customers who would often complain that the women's bathroom would be locked. Now this is something we never did while I worked there…they were always open for customers to use. I recall one evening in particular that me and my co-worker found particularly amusing. Once again the women's bathroom was locked; my co-worker and I were the only ones currently on shift. I retrieved the key for a customer—it was an older-style key, not modern. I put it in the doorknob, turned the lock and suddenly the key turned the opposite way back to the locked position. I did it repeatedly, and each time the key would return back into the locked position. Laughing, we finally said, 'Sarah stop,' and it stopped."

Patricia went on to share memories while working in the bar. She explained of often stacking glasses in the glass rack positioned above the bar. "The glass rack had multiple rows that went the length of the bar, and it was able to house at least five glasses back, in each row. On multiple occasions, after stacking the glasses securely in the rack, the glasses would suddenly shoot out from the rack by themselves, crashing upon the bar or onto the floor. This happened often and to other co-workers as well," she explained.

Another resident, SILKA JEWELL, resided at the Brookdale Lodge in 1996. This is her experience: "My sister Aurora and I lived in a basement apartment at the back-right wing, which burned down in 2009. We lived there for almost a year. Many odd things happened while we lived there.

I remember the lights and television would turn off and on on their own. The faucets would turn on by themselves. One night I woke up. I had fallen asleep on the couch, and when I awoke, there was a young girl in a bathing suit looking at me. She then vanished. My sister had a similar experience. She was in her room playing guitar, and when she looked up, there was a young girl in an old-style dress staring at her and smiling. Then she just…faded away. I also had been in the bar one evening drinking and saw a young girl in the Mermaid Room in my peripheral vision. When I turned to actually look, she was gone. I loved living there. It was a nice little community, and the experiences were awesome."

SARAH (who requested her last name be omitted), another witness to the ghostly taunts of the Brookdale Lodge, experienced the following: "In 1998, I was looking at possible wedding sites in Santa Cruz, and having lived here most of my life, I added the Brookdale Lodge to my list. I visited with a friend on a sunny afternoon, and the hostess welcomed us to walk around on our own to take a look at the lodge. My friend and I went in different directions to look around. I was in the creek-side dining room on the elevated walkway that circled the entire room, and I had the distinct impression of a child walking up behind me and pulling on the back hem of my shirt—so much so that I turned around with this idea that I was going to say, 'What are you doing?' or something like that, and there was no one there. I wasn't afraid but more confused because I was sure I was going to see someone there and almost thought of it as a joke, which maybe it was. We did eventually find a facility, but it wasn't the Brookdale Lodge. I'd love to have our twentieth wedding anniversary party there though, and the ghosts are welcome, too."

Although there have been numerous encounters with what many believe to be the playful spirit of little Sarah Logan, there are those who have experienced something much different.

DENISE DALTON, former head of housekeeping of the Brookdale Lodge and featured on the paranormal series *Ghost Adventures,* had a violent encounter with a negative spirit. In 2010, Dalton was walking in the hall near the bar area when something aggressively pushed her from behind. The push was so forceful that she did not even have time to put her hands up to brace herself from the fall. While on the floor, a Hispanic employee began yelling and pointing from behind the bar, "Phantasma! Phantasma!," pointing at a dark shadowy mass that was hovering above Dalton as she lay on the floor. When

she recovered, blood was pouring from her face. The bone of her nose was protruding from the skin. Shaken and afraid as to what had just occurred, Dalton was taken to the hospital. X-rays revealed a severely broken nose. Upon further examination, doctors noticed a large red handprint on Dalton's back. Not believing her story about how she got her injuries, the attending physician requested a domestic violence therapist to counsel Dalton.

To this day, Denise Dalton's life continues to be affected by the memories of that fateful encounter. Although she is still filled with fond memories of the Brookdale Lodge, Dalton believes without a shadow of a doubt that something dark and malevolent also wanders the halls of the World Famous Brookdale Lodge.

Playwright ED SAMS visited the Brookdale Lodge in 1991. This is what he experienced: "In 1991, my wife, Sally, and I wrote a one-act play called *Spirits of the Brookdale Lodge* that Mountain Community Theatere performed as a staged play reading. To prepare for the play, the cast visited the Brookdale Lodge and was given a tour of the Brookside Room, which was closed at that time. We were particularly interested in the 'killing room,' as it was called then, which was a room off the kitchen where chickens were killed to be served for meals. A report in the *Scotts Valley Banner* claimed that devil-worshiping graffiti was scrawled on the wall there. As we looked for these signs, our flashlights hit upon a secret room in the ceiling that was patterned in rose leaf wallpaper, perhaps one of the hideouts that mobsters used during the lodge's bootlegging era. The graffiti we found was nothing more than a Dead Kennedys logo, but as we left, the last member of the cast, Bob Marr, suddenly let out a cry, 'Stop that!' All our flashlights turned on him. He looked sheepish and said, 'I felt someone tug on my ear.' It was as if some lonely little ghost in the secret room did not want us to leave."

JANINE KOPPING, another hotel guest, recalled her ghostly encounter: "I checked into the Lodge on October 30, 2010. My roommate and I had dinner in Brook Room. We were familiar with the ghost stories and later headed out to explore. We found ourselves in the original cabin. I took a lot of random pictures hoping to catch 'something.' I randomly snapped photos in the log cabin. No flash. Almost pitch black except for the light coming thru the slats in the windows. The room felt thick and oppressing. I was completely creeped out by the fireplace. I later discovered the disturbing image of what appears to be the ghostly apparition of a woman, screaming in agony.

I had an old Cannon digital, and the picture window for viewing was maybe half-inch square. It was Halloween night, and a friend of ours' band was playing at a local bar down the road. A séance was scheduled at midnight at the lodge, and initially we had no intention of going to it. However, after seeing the photo we changed our minds. We got back to Brookdale just before midnight. There were maybe thirty or so people already seated. The only available seats left were at a table not far from the cabin doorway! The door had been left wide open. While the hosts and 'psychic Nancy Bowman' started their program, I kept looking toward the cabin door. All of a sudden, I became completely overwhelmed with the most intense feeling of sadness and despair I have ever felt. I began to quietly sob. I remember saying to my friends, 'She is stuck here. She can't leave. All she wants to do is leave and she can't.' I remember repeating that several times. Tears were streaming down my face, and I could not stop them. Fortunately, there was a lady sitting across from me that was able to help and get me grounded and get rid of whatever had taken over me. During this fifteen-minute or so ordeal, the moderators had 'shushed' us several times. They had no idea what was happening. The rest of that evening was uneventful, thank God. We checked out the next morning, and it was shortly after that we heard of the unfortunate closing of the lodge. I would like to go back again one day. I will make sure I am with a paranormal expert when I do!"

JESSIE GARCIA, a veteran paranormal investigator with ten years of investigative experience and four hundred locations both nationally and overseas under his belt, is the founder and lead investigator of San Jose Paranormal. Garcia has investigated the Brookdale Lodge on several occasions. In October 2010, he revisited the lodge with his paranormal investigative team. Jessie Garcia shared his experiences:

"I was investigating in the Mermaid Room with a few other investigators. We were trying to get a reaction from any spirits that were in the room. So we started to play period music and started to dance in the middle of the dance floor, at the same time asking what or whoever was in the room if they could turn on the disco ball. We were all dancing for about five minutes when the disco ball came on. It was for like a split second, but it amazed all of us.

I remember the very first time I encountered the dark entity which was in the log cabin room. I walked in there and was fascinated because I love old-style buildings. Inside the cabin, there is a shed with real wood shingles. It was just me in the room, and I walked toward the shed to see what was

inside it. Before I got there, I heard this noise coming from it. It sounded like wood splitting. All of a sudden, with great force, a piece of the shingle was thrown at me. Something had ripped it from the roof and thrown it at me. I looked all around the room, and there was no one else there. I had been to the lodge numerous times by this point. I think the spirits of the lodge had familiarized themselves with me and were interacting with me on a regular basis, especially the man in the log cabin room. On this occasion, I was standing in the middle of the room with two other investigators talking ghosts when out of nowhere I heard and felt a *snap* on my right cheek and my head turned to the left. The other investigators looked at me in awe. We couldn't believe what had just happened. Whatever it is in the log cabin, it doesn't like me."

Within the last ten years, the Brookdale Lodge has endured many dark days, leaving its hull vacant and its doors locked. However, today, the World Famous Brookdale Lodge is yet again under new ownership, with another hotelier who will be responsible for its history in the remaking, Mr. Pravin Patel. Patel aspires to make the Brookdale Lodge "World Famous" once again. Ensuring that the lodge meets city code requirements, as well as conducting extensive renovations to its façade, the task will be a historic one once complete—once again resurrecting the legendary World Famous Brookdale Lodge for all to enjoy and creating a new history for generations to come. As for the spirits that dwell within, one can only speculate. Perhaps they, too, anxiously await the awakening of the Brookdale Lodge, as its waters continue to flow through its sleeping, beating heart.

In memory of Nancy Bowman,
The Beating Heart of Brookdale Lodge

SOURCES

PEOPLE AND ORGANIZATIONS

Barry Brown, historian
Denise Dalton
Reverend Carl Faria, Monterey Diocese
Jessie Garcia, San Jose Paranormal
Ashley Hernandez
William Horn
Tom Howard, Gilroy Historical Museum
Silka Jewell
Janine Koppling
Rhiannon Mai
Mount Madonna Camp Ground Ranger Station
Marla No-Sangye Hawke, Santa Cruz Museum of Art and History
Marla Novo
Kathy Oliver
Pravin Patel
Beverly Pendergraft, research
Researchers Anonymous
Martin Rizzo, Holy Cross researcher on Father Quintana
Patricia Rothfuss
Ed Sams
San Lorenzo Valley Museum

Sources

Santa Cruz Library
Santa Cruz Museum of Art and History
Deena Smith
Tuttle Mansion
Watsonville Historical Society
Jennifer Oliver Wess
Wenna Yechone

Books

Genell, Megan. *The Spanish Missions of California*. American History Paperback. N.p.: True Books, September 1, 2010.

Margolin, Malcolm. *The Ohlone Way: Indian Life in the San Francisco–Monterey Bay Area*. 2nd ed. Berkeley, CA: Heyday, 1978.

Ostrow, Kim. *Mission Santa Cruz*. Missions of California Series. N.p.: PowerKids Press, 2004.

Strickland, Shelly. *Notorious Criminal Case Study of Edmund Kemper*. N.p., 2013.

Weber, Francis. *The California Missions*. N.p., 2005.

Website Links

http://criminalminds.wikia.com/wiki/Herbert_Mullin.
http://dustytreasuresantiques.com/the_historic_tuttle_mansion.
http://factcards.califa.org/mis/santacruz.html.
http://home.earthlink.net/~herblst/tuttle_family.htm.
http://indiancanyon.org/QuirosteAttack1793.html.
http://missiontour.org/wp/santacruz/mission-santa-cruz.html.
http://murderpedia.org/male.F/f/frazier-john-linley.htm.
http://noehill.com/santacruz/nat1975000482.asp.
http://santacruzmah.org/guides/guide-to-the-california-powder-works-photo-album-collection/guide-to-the-california-powder-works-photo-album-collection-1890-history.
http://scplweb.santacruzpl.org/history/work/capowder.shtml.
http://usatoday30.usatoday.com/money/economy/housing/closetohome/2008-06-23-santa-cruz-california_N.htm.

http://www.amazon.com/Ghosts-Gulch-Evergreen-Cemetery-Mysteries/ dp/1505459583.

http://www.athanasius.com/camission/cruz.htm.

http://www.biography.com/people/edmund-kemper-403254.

http://www.forgottenusa.com/haunts/CA/2792.

http://www.history.com/topics/al-capone.

http://www.holycrosssantacruz.com.

http://www.indiancanyon.org/OhloneYokutCruz.html.

http://www.legacy.com/obituaries/santacruzsentinel/obituary. aspx?pid=173308635.

http://www.metroactive.com/papers/cruz/10.29.03/haunting-0344.html.

http://www.militarymuseum.org/deBouchard.html.

http://www.missionscalifornia.com/journeys/santa-cruz.html.

http://www.mobileranger.com/santacruz/father-quintanas-grisly-death- at-mission-santa-cruz-2.

http://www.murderpedia.org/male.F/f/frazier-john-linley-photos.htm.

http://www.murderpedia.org/male.K/k/kemper-edmund.htm.

http://www.murderpedia.org/male.M/m/mullin-herbert.htm.

http://www.santacruz.com/news/santa_cruzs_most_notorious_lynching.html.

http://www.santacruzpl.org/history/articles/11.

http://www.santacruzpl.org/history/articles/248.

http://www.santacruzpl.org/history/articles/25.

http://www.santacruzpl.org/history/articles/653.

http://www.santacruzpl.org/history/articles/75.

http://www.santacruzsentinel.com/20151019/sarah-miller-daughter-of- cattle-king-henry-miller-said-to-haunt-mount-madonna.

http://www.santacruzsentinel.com/article/NE/20151019/ NEWS/151019688.

http://www.santacruzsentinel.com/article/zz/20090819/ NEWS/908199841.

http://www.santacruzsentinel.com/article/zz/20110528/ NEWS/110527640.

http://www.serialkillers.ca/edmund-kemper.

http://www.superiorbookpromotions.com/superior_book_reviews/ TheCurseofSantaCruz.html.

http://www.travelchannel.com/shows/ghost-adventures/episodes/ brookdale-lodge.

http://www.weirdfresno.com/2011/06/gilroys-haunted-mount-madonna- county.html.

https://en.wikipedia.org/wiki/Al_Capone.

https://en.wikipedia.org/wiki/Edmund_Kemper.

https://en.wikipedia.org/wiki/Herbert_Mullin

https://en.wikipedia.org/wiki/John_Linley_Frazier.

https://en.wikipedia.org/wiki/Ohlone_people.

https://en.wikipedia.org/wiki/The_Birds_(film).

https://localwiki.org/santacruz/Paradise_Park_Masonic_Club.

https://www.dioceseofmonterey.org/santa-cruz-holy-cross.aspx.

https://www.newspapers.com/clip/2264375/another_mt_madonna_
death_by_murderer.

https://www.newspapers.com/clip/3330207/aug_1913_powder_works_
mill_burning.

https://www.newspapers.com/clip/3330265/jan_20_1917_marriage_of_
myrtle.

https://www.newspapers.com/clip/3423972/sarah_alice_miller_
jun_18_1879_death.

https://www.newspapers.com/clip/3423990/sarah_alice_miller_mt_
madonna.

https://www.newspapers.com/clip/3424083/murder_of_expectant_
mother_oct_1_1969.

https://www.newspapers.com/clip/3424277/torturous_stabbing_of_2_
teenage_boys_on.

https://www.newspapers.com/clip/3424315/1936_jack_bennett_blows_
his_head_off_in.

https://www.newspapers.com/clip/3428670/mt_madonna_murder_1944.

https://www.newspapers.com/clip/3500597/mclaughlin_kills_daughter_
then_commits.

https://www.newspapers.com/clip/3643255/marie_holms_suicide_book_
vers.

https://www.newspapers.com/clip/4030185/1933_sep_11_shooting_of_
grace_mccray.

https://www.newspapers.com/clip/4075706/hotel_mccray_and_herbert_
mullin_page_2.

https://www.newspapers.com/clip/4131272/mclaughlin_notice_to_
creditors_mar_14.

https://www.newspapers.com/clip/4131496/mclaughlin_chimmney_
falling.

https://www.newspapers.com/clip/4131623/newark_man_claims_to_
have_been.

https://www.newspapers.com/clip/4157426/mclaughlin_house_1982.

https://www.newspapers.com/clip/4157465/mclaughlin_and_henry_cowell.

https://www.newspapers.com/clip/4203848/clip_mclaughlin.

https://www.newspapers.com/clip/4205605/lloyd_auerbach_brookdale_ghosts.

https://www.newspapers.com/clip/4641140/logan_water_system_city.

https://www.newspapers.com/clip/4641181/logan_1891_surf_news_paper.

https://www.newspapers.com/clip/4643105/1910_history_of_judge_logan.

https://www.newspapers.com/clip/4643459/logan_assaulted_horse_whip_1896.

https://www.newspapers.com/clip/4643958/brookdale_lodge_minihaha_tribe_1887.

https://www.newspapers.com/clip/4668908/death_of_mrs_logan_brights_disease_1909.

https://www.newspapers.com/clip/4669757/triple_drowning_brookdale.

https://www.newspapers.com/clip/4670272/brookdale_lodge_boxer_killed_1962.

https://www.newspapers.com/clip/4670872/santa_cruz_sentinel.

https://www.newspapers.com/clip/4670878/brookdale_lodge_fliers_memory_attends.

https://www.newspapers.com/clip/4670931/brookdale_lodge_amelia_earhart_1938.

https://www.newspapers.com/clip/4703098/new_brookdale_lodge_rises_jun_1957.

https://www.newspapers.com/clip/4703256/brookdale_lodge_redesigned_1960.

https://www.newspapers.com/clip/4704570/brookdale_lodge_bankruptcy_1964.

https://www.newspapers.com/clip/4704785/brookdale_lodge_fire_1966.

https://www.newspapers.com/clip/4705011/brookdale_lodge_1965_slv_man_slain.

https://www.newspapers.com/clip/4705041/brookdale_lodge_1962_fraud_b_morrow.

https://www.newspapers.com/clip/4705244/brookdale_body_of_missing_slv_man_found.

https://www.newspapers.com/clip/4705307/brookdale_lodge_assualt_1970.

https://www.newspapers.com/clip/4705607/brookdale_flood_3242_inches_of_rain.

https://www.newspapers.com/clip/4711511/bomb_brookdale_lodge_1983.

https://www.newspapers.com/clip/4711531/bombing_of_brookdale_lodge_1983.

https://www.newspapers.com/clip/4763034/aj_sloan.

https://www.newspapers.com/clip/4764457/judge_blackburn.

https://www.newspapers.com/image/106271924/?terms=Weltz.

https://www.newspapers.com/image/107186841/?terms=Weltz.

https://www.newspapers.com/image/23721649/?terms=Edmund%2BKemper.

https://www.newspapers.com/image/27584507/?terms=Powder%2BWorks%2BMill.

https://www.newspapers.com/image/2965654/?terms=birds.

https://www.newspapers.com/image/36797079/?terms=John%2BLinley%2BFrazier.

https://www.newspapers.com/image/3713225/?terms=John%2BLinley%2BFrazier.

https://www.newspapers.com/image/46408479/?terms=Powder%2BWorks%2BMill.

https://www.newspapers.com/image/46558419/?terms=Powder%2BWorks%2BMill.

https://www.newspapers.com/image/47598048/?terms=Weltz.

https://www.newspapers.com/image/50450021/?terms=Myrtle%2BRountree.

https://www.newspapers.com/image/50472769/?terms=Iowa%2BTuttle.

https://www.newspapers.com/image/50513716/?spot=4149963.

https://www.newspapers.com/image/50577457/?terms=Henry%2BRispin.

https://www.newspapers.com/image/50930914/?terms=Henry%2BRispin.

https://www.newspapers.com/image/51371144/?terms=Powder%2BWorks%2BMill.

https://www.newspapers.com/image/51372382/?terms=judge%2Borders%2Bhair%2Bshaved.

https://www.newspapers.com/image/52030189/?terms=Weltz.

https://www.newspapers.com/image/52031840/?terms=Weltz.

https://www.newspapers.com/image/52031982/?terms=Weltz.

https://www.newspapers.com/image/52038659/?terms=Weltz.

https://www.newspapers.com/image/52038921/?terms=Weltz.

https://www.newspapers.com/image/52039065/?terms=Weltz.

https://www.newspapers.com/image/52039335/?terms=Weltz.

https://www.newspapers.com/image/52039568/?terms=Weltz.

https://www.newspapers.com/image/52040146/?terms=Weltz.

https://www.newspapers.com/image/53928962/?terms=Powder%2BWo rks%2BMill.

https://www.newspapers.com/image/53965390/?terms=Henry%2BRisp in.

https://www.newspapers.com/image/53984654/?terms=Alfred%2BHitc hcock.

https://www.newspapers.com/image/53986412/?terms=Alfred%2BHitc hcock.

https://www.newspapers.com/image/60474102/?terms=Alfred%2BHitc hcock.

https://www.newspapers.com/image/60501779/?terms=birds.

https://www.newspapers.com/image/60501779/?terms=Sea%2BBird%2 BInvasion.

https://www.newspapers.com/image/60501849/?terms=Capitola%2Bbirds.

https://www.newspapers.com/image/60501979/?terms=Alfred%2BHitc hcock.

https://www.newspapers.com/image/60501979/?terms=Alfred%2BHitc hcock.

https://www.newspapers.com/image/60932091/?terms=Dr.%2BOhta.

https://www.newspapers.com/image/60932303/?terms=Dr.%2BOhta.

https://www.newspapers.com/image/60932676/?terms=John%2BLinley %2BFrazier.

https://www.newspapers.com/image/60933047/?terms=Dr.%2BOhta.

https://www.newspapers.com/image/60933292/?terms=John%2BLinley %2BFrazier.

https://www.newspapers.com/image/60934259/?terms=John%2BLinley %2BFrazier.

https://www.newspapers.com/image/61056195/?terms=Alfred%2BHitc hcock.

https://www.newspapers.com/image/61229575/?terms=John%2BLinley %2BFrazier.

https://www.newspapers.com/image/61875916/?terms=Herbert%2BM ullin.

https://www.newspapers.com/image/62391820/?terms=Henry%2BRispin.

https://www.newspapers.com/image/63451240/?terms=Edmund%2BKemper.

https://www.newspapers.com/image/66119850/?terms=Edmund%2BKemper.

https://www.newspapers.com/image/66121850/?terms=Edmund%2BKemper.

https://www.newspapers.com/image/66123017/?terms=Edmund%2BKemper.

https://www.newspapers.com/image/66221204/?terms=Herbert%2BMullin.

https://www.newspapers.com/image/70556922/?terms=birds.

https://www.newspapers.com/image/81001393/?terms=Powder%2BWorks%2BMill.

https://www.newspapers.com/image/81001600/?terms=Powder%2BWorks%2BMill.

https://www.newspapers.com/image/82449619/?terms=Herbert%2BMullin.

https://www.newspapers.com/image/92192944/?terms=Herbert%2BMullin.

https://www.newspapers.com/image/95238261/?terms=Henry%2BRispin.

https://www.newspapers.com/image/95415530/?spot=4149879.

montereybaysanctuaries.net/goldengatevilla/historic/index.php.

About the Author

Maryanne Porter is a native of Santa Cruz, California, and has loved urban legends, myths, folklore and mysteries since childhood. In college, she majored in criminal justice, taking a deep interest in psychology, criminal behavior and law. In her later years, she developed a passion for history, particularly unusual history, which later fueled a desire to research local legends, folklore and the paranormal. Not satisfied with just watching paranormal shows on television, she decided to venture out on her own and further explore supernatural phenomena, and this resulted in an aspiration to research and combine paranormal findings with historical legends. Santa Cruz Ghost Hunters was born.

By 2012, she had purchased the rights to Santa Cruz Haunted Tours, allowing for individuals from all over to also experience what it is to be a paranormal investigator and to learn the haunted legends of Santa Cruz County. To date, she has taken her haunted tours one step further, engaging in new prospects with Brookdale Lodge owner Pravin Patel in order to bring Santa Cruz Haunted Tours and SCGH on location to the haunted World Famous Brookdale Lodge for all to enjoy.

With her love of writing, she aspires to continue creating ghostly tales, taken from historical accounts and local lore combined with a speculative perspective in order to bring forth more enjoyable tales of haunted Santa Cruz and beyond.

For more information about the author or Santa Cruz Ghost Hunters and the whole team, please visit their website at santacruzghosthunters.com. Here you can read about their adventures and also share yours.